Collins *gem*

Wild Animals

John A. Burton

First published in 2009 by Collins,
an imprint of HarperCollins Publishers Ltd.
77–85 Fulham Palace Road
London
W6 8JB

www.collins.co.uk
Collins is a registered trademark of HarperCollins Publishers Ltd.

Text © John A. Burton 1996, 2009

8 7 6 5 4 3 2 1
12 11 10 09

A catalogue record for this book is available from the British Library.

ISBN: 978-0-00-728410-8

Collins uses papers that are natural, renewable and recyclable
products made from wood grown in sustainable forests.
The manufacturing processes conform to the environmental
regulations of the country of origin.

Proofread by Janet McCann
Designed by Martin Brown
Printed and bound in China by Leo Paper

CONTENTS

This book is designed as an introduction to the mammals, reptiles and amphibians of Europe, with all the major types illustrated. The general introduction describes each of the main groups, such as insectivore, bats, lizards or snakes, and a selection of species is illustrated and described in more detail.

Each of the groups is indicated by a small symbol at the top of the page.

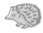
Primitive mammals, mostly small, feeding on invertebrates, or occasionally small amphibians, reptiles or mammals.

The only mammals capable of true flight. All European species feed on flying insects and spiders. Most hibernate.

Species entries

The most widely used English names are given, followed by the Latinised scientific name. The scientific name comprises two words, the generic name (which is always capitalised), followed by the specific name (with is never capitalised). A general description is followed by summary notes under the following headings:

Size: The measurements usually refer to the head and body, and the tail length when appropriate. In other species, such as bats, measurements are given for wingspan.

Habitat The most common or typical habitat is described, however it should be taken into account that some species may occur in other similar habitats.

Food: A brief summary of the most usual foods eaten are given although many species may eat a much wider variety of related animals or plants.

Range: This summarises where the species is most likely to be encountered within Europe. It is important to remember that a species is only likely to be found in suitable habitats within its range.

INTRODUCTION
Looking for wild animals

Reptiles, amphibians and mammals, although widespread and often common, are generally more difficult to observe than birds. But a few useful tips may help you to find them.

Mammals

Most mammals are nocturnal, rarely emerging from their dens or roosts before nightfall. However, searching a garden at night, with a strong beam torch, will often reveal a noisy hedgehog snorting in the undergrowth. (When using a torch it is important to remember that the full beam should never be shone directly into the animal's eyes, but always slightly to one side.) Bats can frequently be seen in the twilight, although even experts find them almost impossible to identify precisely in flight. Mice, and even shrews, can be attracted to nocturnal feeding stations by putting out cat food, fishing maggots, seeds and berries. Any small table, similar to a bird table,

can be adapted for this use, but it must be placed near the ground and close to shrubs and bushes. Once small mammals are used to a particular feeding place they will usually become accustomed to artificial light. Some mammals will even use bird nesting boxes, and sometimes will take over bird boxes during the winter months – it is always worth checking these carefully for wood mice and dormice.

Larger mammals, such as deer, ibex and wild sheep, require stealth, patience, and often a pair of binoculars to spot them across valleys or close to the horizon.

To see whales and dolphins you really need to be in a boat, and some of the smaller species will sometimes ride the bow wave of a boat. Larger whales are usually only glimpsed as their back breaks the surface of the sea, or you may be lucky enough to see their 'blow' – the water vapour of their breath.

Amphibians
Amphibians are relatively easy to see, and perhaps the best way is to visit ponds in which they breed in spring. But even if you do not

manage to see them in the breeding season you may well find their larvae, or tadpoles. Amphibians can often be found by searching at dusk or after dark on a warm, wet evening, as this is the time they normally come out to feed. They are often found under outside lights, or you could use a torch to search for them.

Amphibians and reptiles (and some small mammals) can also often be found under logs, sheet iron or planks. But always remember to replace any of these hiding places exactly as you find them, and do not walk on iron sheeting or planks if you know there are animals underneath as your weight could easily damage them.

Reptiles

Most reptiles love basking in the sunshine, and the best time to look for them is when the sun is first beginning to really warm the ground. They are often very shy, scuttling away before you have a chance to get a good look. But if you note where you first saw them and return half an hour later, perhaps using binoculars to see them from slightly further away, there is a very good chance they will have returned to the same basking place.

Always listen too

Listening can also lead you to animals. A gentle, continuous rustling in the undergrowth may indicate a snake slithering away. A short rustle, a pause, followed by another short rustling among dry leaves, often indicates a lizard. Frogs and toads have a variety of distinctive croaks, some loud, some very subdued. Bats emit high-pitched squeaks, only some of which are audible to humans, and even these tend to become inaudible as we grow older and our sense of hearing becomes less acute. Carnivores, however, are often quite noisy, particularly in the breeding season, and you will usually hear them even if you do not see them.

Handling animals

As a general rule it is best only to handle wild animals under the guidance of an expert. An expert will stress the importance of treating all wildlife with caution and will remind you that you must wet your hands before handling

amphibians, and that you should wear gloves if
you are handling most other animals. Some
snakes are poisonous, and although human
fatalities are extremely rare, a bite from them can
be unpleasant. Similarly, while rabies in mammals
is rare, and human fatalities even rarer, some
mammals do carry diseases transmissible to
humans. Particular care should be exercised when
handling sick or injured animals.

The habitats of European wildlife

Arctic tundra
The Arctic is characterised by a very simple
ecosystem with relatively few species.
The vegetation is low, with dwarf willows and
other short trees. Mammals of this region often
have fur that is white in winter, to provide
camouflage in the snow. Because they are cold-
blooded, most reptiles and amphibians are not
well adapted to the Arctic, but the Common
Lizard and Adder (both of which retain their eggs
within the body and are able to incubate them

by sunning themselves), as well as the Common Frog, all manage to breed within the Arctic Circle. Arctic Foxes, lemmings and voles all have populations which are often cyclical, numbers building up over several years then crashing when food becomes scarce.

Deciduous woodland

Much of Europe was once covered in deciduous woodlands, often with huge oaks, hundreds of years old. Remnants of these mighty forests are now reduced to a few isolated pockets in Eastern Europe which means that the wildlife that depends on them is also much rarer than previously. Large mammals such as the Bison, Wolf and Wild Boar, as well as the Pine Marten, are found in the forests, and crevices and hollows in trees, as well as old woodpecker holes, provide ample roosting places for bats. Reptiles, such as the green lizards, occur in the more open areas, and snakes, such as the Grass Snake, breed in rotting vegetation along the rivers. Beneath rotting logs amphibians as well as Slowworms and small mammals may be found hiding in the damp soil.

Wetlands

Swamps and marshes once covered huge areas of Europe, but from the sixteenth century onwards the majority have been drained because they often provided fertile farmlands. In their original state, wetlands provide homes for a wide range of amphibians, particularly frogs and toads, and several species of snake, as well as mammals including Beaver, Otters and Mink. Many bats feed on the insects that infest wetlands, while terrapins and smaller mammals including Water Voles, Water Shrews and Harvest Mice are rarely found more than a few metres from water.

Mountains and coniferous forests

The mountain tops of Europe are still quite rugged, and although tourist development reaches almost all the peaks and summits, it is still possible to find relatively unspoiled valleys and slopes. Close to the snow line several small rodents, such as the Snow Vole, occur and the whistle of the Marmot is one of the characteristic sounds of the Alps in summer. More difficult to see, although their numbers are steadily increasing, are the Ibex and Chamoix. The Alpine

Salamander overcomes the problem of the cold and the short summers by retaining its eggs within the body and giving birth to fully developed young.

Mediterranean and desert habitats
Around the Mediterranean there are many relatively dry habitats, and in parts of Spain, Italy and southeast Europe there are areas that qualify as deserts. It is in these drier habitats that several species of reptile abound. But if you want to observe them, remember that during the hotter months of the year, most species are only active at night or in the early hours of the day, and some may even aestivate (the summer equivalent of hibernation).

Introduced animals

Several species only occur in Europe as a result of being introduced by humans. Sometimes they were introduced for food, sometimes as pets which subsequently escaped and bred, and for others there is no apparent reason. Raccoons, Musk Rat, American Mink and Bullfrog were all

imported from North America. The Coypu originated from South America, the Axis Deer, Muntjac and Chinese Water Deer from Asia. The Barbary Ape, Genet, Mongoose, Porcupine and Chameleon all came from North Africa, and the occurrence of tortoises, tree frogs, hares and rabbits on many Mediterranean islands is almost certainly due to humans moving them around. Generally the introduction of exotic animals is considered detrimental, since they often compete with native wildlife, and may also do considerable damage. The most damaging of all introductions are undoubtedly the rodents – House Mouse, Black Rat and Brown Rat originally came from Asia, and not only do they cause millions of pounds' worth of damage every year, but they are also responsible for diseases such as the plagues that used to wipe out a large proportion of the human population.

Conservation

Many of Europe's mammals, reptiles and amphibians have declined drastically in numbers and several species are now extremely rare.

The original natural vegetation that covered Europe was vastly different from what now covers most of the region. Even the landscape of forty years ago was significantly more suitable for wildlife. From the Iron Age onwards the primeval forests and grassy savannahs were cleared to make way for agriculture, and at the same time the huge wild oxen (Aurochsen) were hunted to extinction. Many other mammals, such as Wolves and Bison, only survived in a few remote parts of Europe, and now need legal protection. Since World War II the destruction of natural habitats has continued and the agricultural landscapes have become increasingly sterile. Flower-rich meadows were 'improved' (with fertilisers) or ploughed, and pesticides and herbicides eliminated weeds and most invertebrates from the arable fields. Hedgerows were ripped out to create larger and larger fields, until most of the landscape of Western Europe is little more than an inhospitable desert for wildlife. Not surprisingly, the populations of many species have plummeted and are now only a fraction of their former numbers. Several species of bat are now endangered, and local extinctions of many species of mammal,

reptile and amphibian have already occurred. These extinctions usually occur on the edges of their range – for instance, in Britain, where Sand Lizards, Smooth Snakes, several bats, and Natterjack Toad are among the most threatened species.

Most countries now have 'Red Data Books' for their wildlife, where threatened species are listed according to the risk of extinction. While hunting and other pressures may affect some species, there is little doubt that the wholesale destruction of natural habitats, such as marshes and forests, coupled with the intensification of farming, have had the most disastrous impact on wildlife.

What you can do

The first step towards helping save wild animals and their habitats is to join an organisation dedicated to conserving them. In the British Isles there are many such organisations, some working at a local level and others regionally. The county Wildlife Trusts are involved in all conservation issues within their county, while

national organisations, such as the Bat Conservation Trust, deal with a particularly threatened group of animals. Public libraries usually have directories of the major organisations, as well as the local ones, and the government bodies responsible for wildlife.

Having joined an organisation, there are several ways you can help. Many offer opportunities for practical conservation activities, which could range from clearing overgrown ponds for amphibians, to putting roosting boxes in conifer plantations for bats. You could also take part in survey work for which even the inexperienced lay person can help, with a minimum of training. These include keeping records of animals found dead on roads, dissecting owl pellets to see what animals they have been eating, or counting breeding frogs in a pond. Most Natural History societies are only too keen to recruit new, enthusiastic members of the public, and they often organise get-togethers and field excursions to help beginners.

MAMMALS
Insectivores

Insectivores are primitive mammals, and some are probably very similar in appearance to the earliest known mammals. They are mostly small (the Pygmy White-toothed Shrew is one of the smallest mammals known, measuring 36–53 mm and rarely weighing more than 2 g), with the hedgehogs being among the largest, growing up to 30 cm long and weighing up to 1.5 kg. Insectivores mostly feed on insects, as well as other invertebrates such as earthworms and molluscs. Their teeth are rather simple pointed pegs that are suitable for holding their prey. The shrews have a very high metabolic rate and spend their lives alternately rushing around searching for food and sleeping. Hedgehogs conserve energy by hibernating during the colder months. The shrews are rarely seen, but their high-pitched squeaks are often heard, and moles are usually detected by their mounds of earth. Hedgehogs are often encountered as road casualties; they have not learned to avoid cars and roll up on their approach.

Hedgehog
Erinaceus europaeus

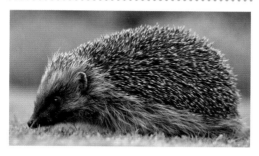

Size Up to 30 cm, tail largely concealed.
Habitat Mostly wooded areas including gardens.
Food Insects, eggs, chicks and other young birds.
Range Widespread and common over W Europe.

The Hedgehog is easily recognised by its spines, which cover its back and sides and are erected by powerful skin muscles. Mainly active at dusk and dawn, it is often very noisy as it searches for insects. It hibernates for up to 5 months in a nest usually made of leaves, and gives birth to 2–9 pink, soft-spined young in late spring or early summer. It sometimes has a second litter.

Algerian Hedgehog

Atelerix (Erinaceus) algirus

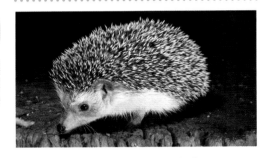

Size Up to 30 cm, including a small tail.
Habitat Usually wooded areas, often gardens.
Food Insects and other small animals.
Range Confined to Mediterranean coastal regions of Spain, France and the Balearic Islands.

This species is very similar to the more wide-spread Hedgehog (p.21). It is most easily distinguished by a parting in the spines on the forehead. It is usually paler, and also has proportionally longer legs. Like the Hedgehog, it is mostly active at night, and most likely to be seen as a road casualty. It does not hibernate.

Mole

Talpa europaea

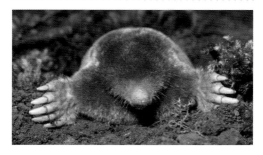

Size Up to 15 cm.
Habitat Grassland and woodland.
Food Mainly earthworms, which it immobilises by biting off the front end, and other invertebrates.
Range Widespread in Europe, except most of the Mediterranean region, Ireland and N Scandinavia.

The Mole has a cylindrical body covered with short, dense black fur. It spends most of its life underground, tunnelling with its pink, spade-like front paws and pushing up molehills at intervals. It is solitary, except during the breeding season, and is active day and night throughout the year.

Common Shrew

Sorex araneus

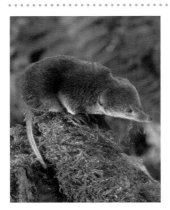

Size 55–85 mm, plus a tail of up to 47 mm.
Habitat Most places with good ground cover.
Food Insects, spiders, snails and other invertebrates.
Range Throughout most of N and E Europe.

The velvety fur is tri-coloured: brownish-black on the back, warmer brown along the sides and greyish-white on the belly. It is generally solitary, except in the breeding season when the female builds a nest of leaves and moss and produces 5–10 young (sometimes 2 litters a year). Active during a 24-hour period, it searches for food at three-hourly intervals. Shrews do not hibernate.

Pygmy Shrew

Sorex minutus

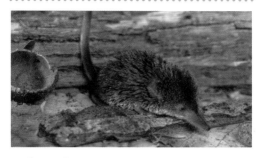

Size 39–64 mm, plus a tail of up to 44 mm.
Habitat Most places with ground cover.
Food Woodlice and other invertebrates and insects.
Range Widespread across most of Europe, except parts of Spain, Portugal and Mediterranean islands.

This shrew is smaller than the Common Shrew, but with a proportionally longer and thicker tail; it is brown above and paler below. It usually lives in burrows made by other animals and builds a nest woven from dry grass. It is also often arboreal (tree-living), and is active both day and night. Up to 2 litters are born a year, each of 2–12 young.

Alpine Shrew

Sorex alpinus

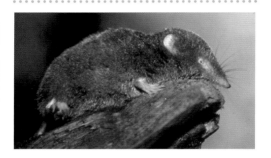

Size 59–83 mm, plus a tail of up to 74 mm.
Habitat Mainly coniferous forest, also alpine meadows and moorland, often near water.
Food Snails, earthworms, insects and spiders.
Range The Alps, and mountains of E Europe.

The Alpine Shrew is blackish-grey with only slightly paler underparts. Like other shrews, the fur is velvety, the snout long and pointed and the legs short. It generally occurs in mountain regions, at altitudes over 500 m up to the tree line; in winter it lives in tunnels beneath the snow.

Water Shrew
Neomys fodiens

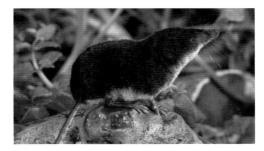

Size 70-96 mm, plus a tail of up to 72 mm.
Habitat Mostly wetlands, preferring clear lakes and slow-moving streams.
Food Fish, frogs and newts; also shellfish and insects.
Range Most of Europe, except much of the SW and SE.

The largest shrew, with blackish fur above and white underneath (although this varies and can be blackish), it has a silvery appearance under water. The tapering tail has a 'keel' of bristles along the underside that acts as a rudder, and the hind feet and toes are fringed with hair, which helps it swim and dive well.

Pygmy White-toothed Shrew

Suncus etruscus

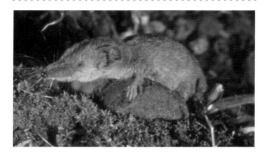

Size 36–53 mm, plus a tail of up to 30 mm.
Habitat Wide variety of fairly dry, but well-vegetated habitats. Prefers sunny open scrub.
Food Small insects, such as grasshoppers, and spiders.
Range Widespread in Mediterranean areas, also the Atlantic coast of France.

This is one of the smallest mammals in the world, and is very elusive. It has largish ears and reddish-brown upperparts; the tail is proportionally longer than other shrews and is 'whiskered'. It nests under stones, logs or tree roots and up to 6 litters are born each year, with 2–6 young in each litter.

Lesser White-toothed Shrew

Crocidura suaveolens

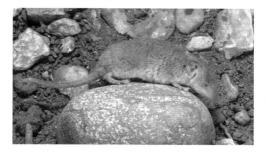

Size 49–78 mm, plus a tail of up to 50 mm.
Habitat Variable; coastal areas, scrub and gardens.
Food Insects and larvae; spiders and beetles.
Range Common and widespread in SE Europe, less common in France, Spain and Portugal.

The Lesser White-toothed Shrew is grey-brown above, sometimes with a reddish tinge, and paler below; it has a long, 'whiskered' tail. It nests under logs and stones and also in burrows – sometimes using those made by other animals. The single litter (occasionally two) has 2–6 young, born naked and helpless.

Bats

Bats are the only mammals capable of true flight. Although some tropical bats are large – with a wingspan of over 1.5 m – those found in Europe are all comparatively small. They range from the pipistrelles, with a wingspan of around 25 cm, up to the Greater Mouse-eared Bat with a wingspan of 45 cm. They all navigate by means of sonar. They emit high-frequency sounds (much higher than the human ear can hear), and use the echo to pinpoint the position of their surroundings. This echolocation enables them to catch their prey, which is mostly small insects. Bats are generally long-lived, many species living around 10 years in the wild. They mostly produce a single young. Except in the extreme south of Europe, bats hibernate, often gathering in large colonies in caves. Nearly all of Europe's bats are considered threatened. Their numbers have declined from a variety of causes that include disturbance during hibernation, poisoning from both agricultural insecticides and timber treatment in houses, and also destruction of roost sites in old trees.

Greater Horseshoe Bat
Rhinolophus ferrumequinum

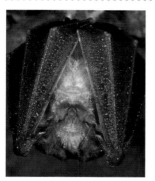

Size 57–71 mm, plus a tail of up to 43 mm, and a wing-span up to 40 cm.
Habitat Wooded countryside with suitable roosts.
Food Mainly flying insects.
Range Patchy distribution throughout Europe, as far north as S Britain and east to the C Russian states.

Bats (Chiroptera)

This bat's name is derived from the flap of skin on its nose, which is shaped like a horseshoe and is often referred to as a 'nose-leaf'. The soft fur on its back is grey-brown, on the underside it is white. It roosts in roof spaces, barns, mines and caves, and hibernates in colonies. The single young is born June–August. It is endangered throughout Europe.

Lesser Horseshoe Bat

Rhinolophus hipposideros

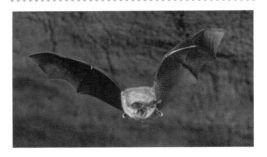

Size 37–45 mm, plus a tail of up to 33 mm, and a wingspan of up to 25.4 cm.
Habitat Wooded countryside; roosts in trees, outbuildings, caves and tunnels.
Food Flying insects and spiders.
Range Declining numbers in S and C Europe, also SW Britain and W Ireland.

One of the smallest bats in Europe, it has pointed ears. It frequently searches for food close to the ground, snatching insects from among rocks. It gives birth to one young a year; in winter it hibernates, often in small clusters.

Daubenton's Bat

Myotis daubentoni

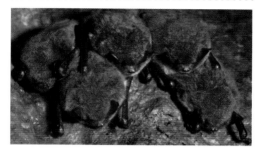

Size 45–55 mm, plus a tail of up to 45 mm, and a wingspan of up to 27.5 cm.
Habitat Open woodland and parkland, near water.
Food Insects, mayflies and midges; occasionally fish.
Range Throughout Europe and parts of British Isles.

These small bats are also known as Water Bats as they often hunt over water, skimming the surface in search of insects, and sometimes taking fish from the water. The fur is reddish-brown above, greyer below, and the feet are proportionally large. It roosts in attics and trees, and in winter usually hibernates underground in caves and tunnels.

Whiskered Bat

Myotis mystacinus

Size 35–48 mm, plus a tail of up to 43 mm, and a wingspan of up to 22.5 cm.
Habitat Woodland and gardens; roosts in hollow trees and bat and bird boxes.
Food Flying insects.
Range All Europe, except Iberia and extreme north.

The smallest *Myotis* bat, the Whiskered Bat has variable coloured shaggy fur which is dark to light brown above and greyer below. It often hunts over water and prefers to hibernate in damp cold places, such as caves and tunnels. A single young is born each year, in mid-June.

Natterer's Bat

Myotis nattereri

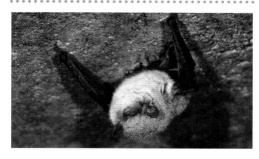

Size 42–55 mm, plus a tail of up to 47 mm, and a wingspan of up to 30 cm.
Habitat Generally wooded areas with good roost sites.
Food Flying insects and spiders.
Range All Europe, north to British Isles and Scandinavia.

This medium-sized *Myotis* bat is light brownish above and whitish below with a pale muzzle and relatively long ears. The tail membrane has a characteristic fringe of hairs along the edge. It is active by night. In summer it roosts in tree holes or cracks in buildings, and in winter it hibernates, on its own or in colonies, usually in caves or tunnels.

Greater Mouse-eared Bat

Myotis myotis

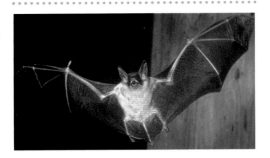

Size 67–79 mm, plus a tail of up to 60 mm, and a wingspan of up to 45 cm.
Habitat Mainly open woodland, but also in towns, where it roosts in church towers and roof spaces.
Food Insects and spiders.
Range Widespread in C and S Europe only.

One of Europe's largest bats, it is grey above and whitish below. The ears are large and mouse-like, and the face is almost hairless. During the breeding season females often form large nursery colonies; the single young is born in early summer and has greyer fur than the adult.

Common Noctule

Nyctalus noctula

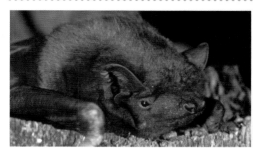

Size 60–80 mm, plus a tail of up to 60 mm, and a wingspan of up to 40 cm.
Habitat Woodland, pasture and parkland.
Food Large insects caught and eaten on the wing.
Range Widespread across most of Europe except N Scandinavia, Scotland and Ireland.

The Common Noctule is a large bat, weighing up to 40 g, with sleek reddish fur and long, narrow wings. It prefers woodland and in winter it hibernates in trees, rock clefts and cracks in houses. Its squeaks are often heard as it emerges at sunset. It flies high and makes sudden twisting dives.

Leisler's Bat

Nyctalus leisleri

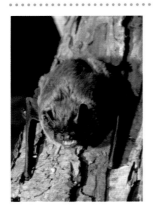

Size 48–68 mm, plus a tail of up to 45 mm, and a wingspan of up to 32 cm.
Habitat Woodland.
Food Moths, beetles and other flying insects.
Range Fragmented across most of Europe, east to the Russian states and south to Greece and Bulgaria.

Similar to the Common Noctule (p.37), but smaller and noticeably darker; it does not fly as high or dive as steeply. During the summer it roosts mainly in tree holes, but occasionally in buildings, with breeding colonies of up to several hundred females. One litter is born each year with a single young in the west of its range, and twins in the east.

Serotine

Eptesicus serotinus

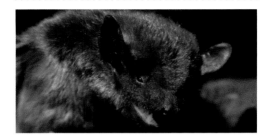

Size 62–82 mm, plus a tail of up to 59 mm, and a wingspan of up to 38 cm.
Habitat Woodland and parks, near human habitation.
Food Insects.
Range Widespread and often abundant across Europe, as far north as S England and Wales.

This large, fairly heavily built bat has dark brown fur and rounded, blackish ears; its underparts are paler. The wings are broad and the flight distinctive – it hunts with a looping flight, often along hedges and edges of woodland. It usually emerges to feed before dark and flies high, rarely twisting and diving.

Northern Bat

Eptesicus nilssoni

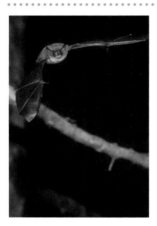

Size 45–64 mm, plus a tail of up to 50 mm, and a wingspan of up to 28 cm.
Habitat Mainly open woodland; also around farms.
Food Insects.
Range Widely in Scandinavia (the only bat north of the Arctic Circle), south to N Romania.

Smaller than the Serotine (p.39), the Northern Bat has longer, less rounded ears.
The fur is brown, tinged with yellow above giving it a glossy sheen, and paler below. It is fast-flying and often hunts over the tops of trees or above water. The females gather in nursery colonies of up to 60, and have 1–2 young each year.

Parti-coloured Bat
Vespertilio murinus

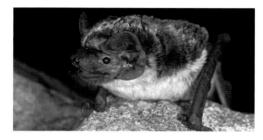

Size 48–64 mm, plus a tail of up to 45 mm, and a wingspan of up to 31 cm.
Habitat Woodland, farms, cliffs; also towns and cities.
Food Insects.
Range C and E Europe, north to S Scandinavia and south to Greece and Italy.

This bat is striking: the hairs on the upperparts are dark brown with white tips, giving it a 'frosted' appearance, which contrasts with the paler undersides. Its flight is fast and straight and it is known to migrate up to 900 km. Originally roosting in cliffs and rocky hillsides, more recently it has adapted to urban areas including tower blocks.

Common Pipistrelle

Pipistrellus pipistrellus

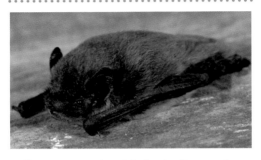

Size 32–51 mm, plus a tail of up to 36 mm, and a wingspan of up to 24 cm.
Habitat Most habitats, except heavily built-up areas.
Food A wide variety of small insects.
Range Most of Europe except the extreme north.

This is the most widespread (and smallest) of the 4 species of pipistrelles, which are Europe's smallest bats. Its colour is variable, but is generally brownish above and paler below. The ears and muzzle are dark and the short ears are rounded. In Eastern Europe roosts of up to 100,000 individuals have been found in caves.

Kuhl's Pipistrelle
Pipistrellus kuhlii

Size 40–47 mm, plus a tail of up to 34 mm, and a wingspan up to 24 cm.
Habitat Mostly woodland.
Food Insects and spiders.
Range S Europe and W France.

Very similar to the Common Pipistrelle (p.42), but generally slightly paler. On close examination it has proportionally broader wings and a shorter thumb – but these characteristics cannot be seen in flight. During the breeding season the females gather in small nursery colonies of around 20 individuals, and give birth to twins.

Brown Long-eared Bat

Plecotus auritus

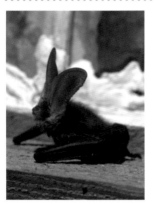

Size 42–55 mm, plus a tail of up to 55 mm, and a wingspan of up to 28.5 cm.
Habitat Woodland and gardens.
Food Insects and spiders; moths in summer.
Range Throughout most of Europe.

The ears of this bat are almost as long as the body and are joined together at the base by a membrane fold along the forehead. It usually emerges after sunset, and has a hovering flight as it hunts for food along the edges of woods. It rarely migrates and does not breed until 2 or 3 years old.

Grey Long-eared Bat
Plecotus austriacus

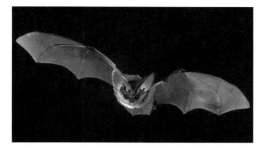

Size 42–58 mm, plus a tail of up to 55 mm, and a wingspan of up to 30 cm.
Habitat Woodland and gardens.
Food Insects and spiders; moths in summer.
Range Across most of S Europe; rare in S England.

This medium-sized bat is almost black on the back and sides, and only slightly paler below; the fur has a 'frosted' appearance. The ears, while quite short, are very large and meet over the head; the face has a characteristic wrinkled appearance. It hibernates in caves, tunnels and trees, and a single young is born in summer.

Pond Bat

Myotis dasycneme

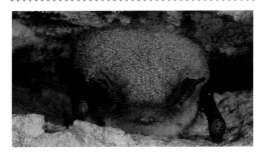

Size 57–68 mm, plus a tail of up to 53 mm, and a wingspan of up to 32 cm.
Habitat Feeds in woodland and meadows; roosts in buildings, caves and cellars.
Food Insects
Range E and C Europe, west to Belgium and NE France, north to Sweden and south to Slovakia.

The Pond Bat is grey-brown above, greyish below and has large, sparsely haired feet. It is critically endangered, probably due to poisoning from timber treatment chemicals. It hibernates singly or in small clusters.

Rabbits and Hares

Rabbits and hares (lagomorphs) are rather similar to rodents, and were at one time classified with them. The most important difference is in the teeth – lagomorphs have tiny secondary incisors behind the upper incisors. The European species differ from the rodents by having long ears, relatively long hind legs, and short fluffy tails. The European Rabbit is colonial and lives in extensive colonies known as warrens; the young are born blind and helpless. It is the ancestor of the domestic rabbit, which now occurs in a wide range of colours, as well as lop-eared varieties, angoras (with long fur) and rex (with short velvety fur). The hares are generally less gregarious, though some species will form herds during winter months. Hares give birth to fully furred young, with their eyes open. Rabbits and hares have been important game animals over most of Europe.

In spring, groups of Brown Hares can be seen 'boxing', part of their courtship behaviour.

Rabbit
Oryctolagus cuniculus

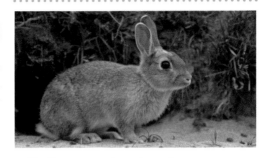

Size Up to 55 cm, plus a short tail.
Habitat Grassland, meadows and scrub.
Food Grass, leaves and crops.
Range Widespread throughout most of W Europe.

Originally from northwest Africa, Spain and Portugal, the Rabbit was introduced and has spread through most of Europe. Although they are usually brown, black individuals are not uncommon. They are mainly active at dusk and dawn and live colonially, having 2 or 3 litters a year of 2–8 young. When alarmed they stamp their hind feet as a warning.

Cottontail
Sylvilagus floridanus

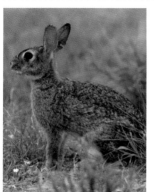

Size Up to 43 cm, plus a tail of up to 65 mm.
Habitat Agricultural land, scrub and thickets.
Food Grass and vegetation.
Range Introduced into France and N Italy.
Similar species Rabbit.

The Cottontail is very similar to the Rabbit (p.48), but is smaller and has shorter, black-tipped ears. It was introduced into Europe from the USA and its range is spreading; it may be displacing the native European species. Unlike the European Rabbit it does not excavate burrows, but gives birth to 3–4 young in a nest above ground.

Brown Hare
Lepus europaeus

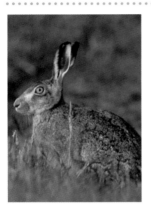

Wild Animals

Size Up to 70 cm, plus a tail of up to 11 cm.
Habitat Open woodland and grassland.
Food Grasses, shoots, twigs and leaves.
Range Across Europe, except N Scotland, Ireland, N Scandinavia and much of Spain and Portugal.

Hares are sandy brown above, lighter below and have long, black-tipped ears; the tail has a black top. Usually solitary, they do not dig burrows, but scrape a depression (form) in the ground. They can run at a great speed and frequently twist and change direction in mid-air. The 1–5 young (leverets) are born fully furred and are active within a few hours.

Mountain Hare
Lepus timidus

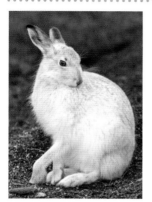

Size Up to 65 cm, plus a tail of up to 8 cm.
Habitat Open tundra, heathland, farmland and mountains.
Food Grasses, heather, sedges and twigs.
Range Scandinavia, Finland and the E Russian states; also Scotland, Ireland, the Faeroes, Alps and Pyrenees.

Distinguished from the Brown Hare (p.50) by its shorter ears and an all-white tail; most populations turn white in winter, except for the black ear-tips. However, in Ireland (and elsewhere at lower altitudes) the summer coat is brighter and only fades slightly in winter. It has 2 or 3 litters a year of 2–5 young, which are active soon after birth.

Tracks and Signs I

Vole

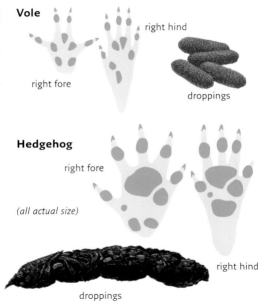

right hind

right fore

droppings

Hedgehog

right fore

(all actual size)

right hind

droppings

52

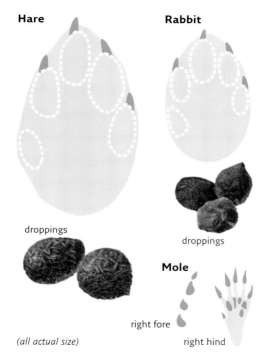

Hare

Rabbit

droppings

droppings

Mole

right fore

right hind

(all actual size)

Rodents

Rodents are the most numerous group of mammals in the world – there are more species of rodent than any other group, and there are more individuals. They are also among the most serious pests, causing millions of pounds-worth of damage to crops and property. The rodents include rats, mice, squirrels, beavers, dormice and several other families. They all have almost identical teeth, consisting of a pair of incisors on the upper and lower jaws, a gap (the diastema) and a row of grinders. The incisors are usually pigmented yellowish or bright orange. Most rodents are herbivores, feeding on leaves, seeds, nuts and other vegetable matter, but many will also feed on insects, grubs and even carrion. Their external appearance is more varied – some have long tails, others almost no tail. Some are aquatic, others are arboreal (live in trees). Although most are relatively dull coloured – usually brown or grey – a few have quite distinctive markings. Most give birth to naked, blind and helpless young, with sometimes as many as 12 or more in a litter.

Red Squirrel
Sciurus vulgaris

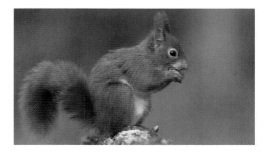

Size 18–27 cm, plus a tail of up to 20 cm.
Habitat Woodland, parkland and forest.
Food Shoots, nuts, fruits and bark.
Range Widespread over most of Europe, except parts of Spain and Portugal and much of England.

The Red Squirrel is usually reddish-brown above and whitish below, but black individuals are not uncommon. In summer it has pointed ear tufts and the tail often leaches to a pale cream. It lives in trees, and builds a bulky nest (drey) in tree forks or in hollow trees. The 3–7 young are born blind and helpless.

Grey Squirrel
Sciurus carolinensis

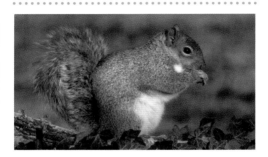

Size Up to 30 cm, plus a tail of up to 24 cm.
Habitat Woodland, parkland and gardens.
Food Nuts, berries, roots and shoots; also insects and eggs.
Range Widespread in England and Wales.

Native to North America, the Grey Squirrel was introduced into Britain at the end of the 19th century. It is larger than the Red Squirrel (p.55), lacks the ear tufts, and is more adaptable – it often lives in close proximity to humans, raiding bird tables etc. The 2 litters a year have 1–7 young each.

Siberian Chipmunk

Tamias sibiricus

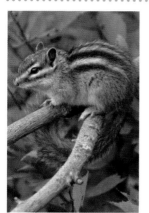

Size 15–22 cm, plus a tail of up to 24 cm.
Habitat Forested areas with thick undergrowth.
Food Nuts, seeds, fruit and roots.
Range E Finland and Russian states, with scattered, introduced populations in France, Germany, Netherlands and Austria.

Originating from Siberia, this small, bushy-tailed squirrel has five clearly defined dark stripes down the back and sides. It is active by day, showing much agility as it leaps from branch to branch, usually in low trees. It has cheek pouches for carrying and storing food, which it hoards for use during the winter, when it is less active.

European Souslik

Spermophilus citellus

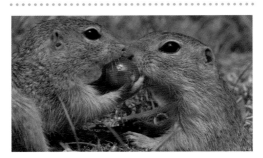

Size Up to 22 cm, plus a tail of up to 4.5 cm.
Habitat Open steppes and arable land.
Food Seeds, grain and herbage, which it stores underground.
Range Widespread in E Europe.

Sousliks have large eyes, short ears and a furry tail, and this species is buff-brown, with no distinct markings. It lives in colonies and sits upright in a 'begging' position as it keeps watch for danger. It is active by day, and excavates extensive underground tunnels, in which it breeds, stores food, and hibernates.

Beaver

Castor fiber

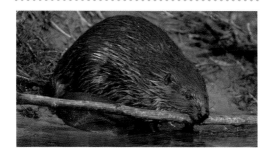

Size 75–100 cm, plus a tail of up to 40 cm.
Habitat Rivers, lakes and swamps, with trees.
Food Bark, shoots, aquatic plants and vegetation.
Range A few isolated colonies on the Rhine, the Elbe (Poland), in Scandinavia and Russia.

The largest rodent in Europe, the Beaver has a blunt muzzle and a flattened, hairless tail. It builds extensive 'lodges' and dams – except populations on the Rhine river in France, which live in burrows instead. It swims well and can stay submerged for up to 15 minutes. Beavers mate for life, and have a single litter a year of 2–6 young.

Garden Dormouse

Eliomys quercinus

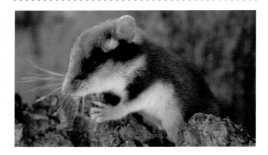

Size 10–18 cm, plus a tail of up to 13 cm.
Habitat Woodland, scrub, orchards, parks and gardens.
Food Invertebrates, nestling birds, eggs and small mammals. In autumn, fruit, berries and seeds.
Range Across most of Europe, except the British Isles, Iceland and Scandinavia.

The Garden Dormouse can be identified by its tail (which has a flattened, black and white tuft at the tip), its black facial mask and large ears. Its nest is built in a cleft in a wall or among rocks, often using an old bird's nest as a base. It is active by night, and has 1–2 litters a year, each of 2–9 young.

Edible Dormouse

Glis glis

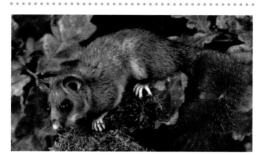

Size 12–20 cm, plus a tail of up to 19 cm.
Habitat Deciduous woodland with dense undergrowth.
Food Buds, bark, fruit; also insects and birds' eggs.
Range Most of Europe, except much of Spain,
Portugal and Scandinavia. Introduced into England.

Also known as the Fat Dormouse, this is the largest
of the dormice. It is grey, except for dark rings
around the eyes, and its tail is long and bushy.
Before hibernation it gorges on food and becomes
very fat; it is so-called because the Romans fattened
them to eat. The 2–7 young are born in early
summer and have been known to live for 9 years.

Hazel Dormouse

Muscardinus avellanarius

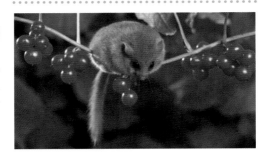

Size 6–8.5 cm, plus a tail of up to 8 cm.
Habitat Woodland with shrubbery; likes honeysuckle.
Food Nuts, seeds, berries and fruit; also insects and occasionally eggs.
Range Most of Europe, except N Spain, Portugal and Ireland.

In size the Hazel Dormouse resembles a large mouse. The fur is bright orange-brown on top and whitish below, and the tail is also furred, giving it a bushy appearance. It is active at night. Its nest is made from stripped bark and it has 1–2 litters a year, each of 2–6 young.

Common Hamster
Cricetus cricetus

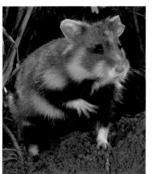

Size 22–34 cm, plus a tail of up to 6 cm.
Habitat Steppes, farmland and grassland.
Food Grain, seeds and roots; also invertebrates.
Range E Europe, also scattered populations west to Belgium and N France.

The Hamster is a burrowing rodent with a plump, furry body and a short, haired tail. Its colour varies: the upperparts are brown with a variety of paler patches, and the underparts are blackish. It lives in colonies in burrows, with chambers for storing food, eating and sleeping, and hibernates in a nest made of leaves or grasses. Up to 3 litters are born a year, each of 3–15 young.

Norway Lemming
Lemmus lemmus

Size 13–15 cm, plus a tail of up to 2 cm.
Habitat Mountain tundra.
Food Grasses, sedges, mosses and shrubs.
Range Norway, Sweden, Finland and Arctic Scandinavia.

The bold golden and black markings on the back make this lemming very distinctive; the underside is paler. In the summer it burrows extensively, in winter it makes its nest in tunnels beneath the snow. The Norway Lemming populations fluctuate dramatically, and they migrate en masse. Four litters or more are born a year, of 2–13 young, which can be mature when 3 weeks old.

Bank Vole

Clethrionomys glareolus

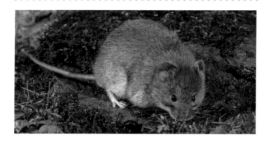

Size 8–12 cm, plus a tail of up to 65 mm.
Habitat Mostly wooded habitats, hedgerows and gardens.
Food A wide variety of vegetable matter including roots, nuts and fungi; occasionally insects and molluscs.
Range Across Europe, except the far north and south.

The Bank Vole is rather mouse-like, but has a blunter nose, more prominent ears and a shorter tail. The fur is reddish-brown, and greyer on the undersides. Active day and night, it makes shallow burrows under grass and leaves, and also climbs among shrubbery. It does not hibernate, and females have up to 4 litters a year, of 3–6 young.

Field Vole

Microtus agrestis

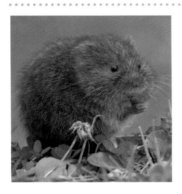

Size 9–14 cm, plus a tail of up to 52 mm.
Habitat Mostly grassy habitats.
Food Grass and vegetable matter; occasionally insects.
Range From N Portugal to E Europe, and north to Great Britain and the Arctic Circle. Absent from much of S Europe and Ireland.

The Field, or Short-tailed, Vole differs from the Common Vole (p.67) in having a longer, shaggier coat. The tail is darker above than below, and the ears slightly hairy. Active by day and night, it tunnels extensively just below ground level and makes its nest of fine shredded grass. Six litters are born a year, each of 2–12 young.

Common Vole
Microtus arvalis

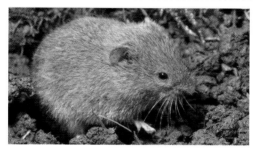

Size 8–13 cm, plus a tail of up to 5 cm.
Habitat Variety of grassland, including pasture.
Food Vegetable matter, berries and some insects.
Range Widespread in mainland Europe from France and Spain to Russia. Introduced into the Orkneys.

Very similar to the Field Vole (p.66), but on close inspection the ears are less hairy; also it is a generally lighter greyish-brown. It burrows deeper than other voles and can therefore survive in areas where there is less ground cover, such as grazed pastures. It is mainly active at night. Up to 6 litters are born a year, each of up to 12 young.

Northern Water Vole

Arvicola terrestris

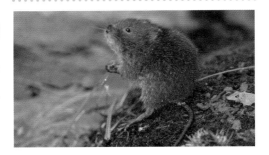

Size 12–19 cm, plus a tail of up to 10 cm.
Habitat Meadows, fields, wetlands and riversides.
Food Mostly vegetation matter; also fish and carrion.
Range Most of Europe except SW France, Spain, Portugal and Ireland.

This large vole varies in colour, but is usually dark brown. Although mainly found in wetlands, it can occur far from water. It is active by day and night, and is often easily visible. When burrowing it makes 'tumps' of soil, similar to those of moles. The 3–4 litters a year each have up to 6 young.

Southern Water Vole

Arvicola sapidus

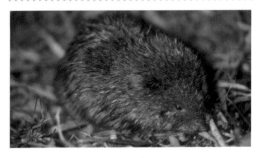

Size 17–20 cm, plus a tail of up to 13 cm.
Habitat Wet meadows, lakes, canals and riversides.
Food Mostly vegetation matter; also fish and carrion.
Range W France, Spain, Portugal.

A large vole very similar to the Northern Water Vole (p.68), but generally larger and darker, and with a proportionally longer tail. Like the Northern Water Vole it is active by day and night, and is often easily visible. It is very rarely seen away from water.

Musk Rat

Ondatra zibethicus

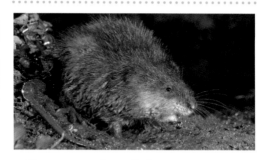

Size 25–40 cm, plus a tail of up to 25 cm.
Habitat Wetlands, lakes and slow-moving rivers.
Food Aquatic plants and most vegetation, some animal matter; also raids food crops.
Range France, east to Russia.

The largest species of vole, with dense, rich-brown fur. Originally from North America, it was introduced into European fur farms and escapees colonised many European countries including Britain, where it was exterminated in 1937. It swims well (having webbed hind feet) and builds nests in aquatic vegetation. It has 1–4 litters a year, of 5–10 young.

Black Rat
Rattus rattus

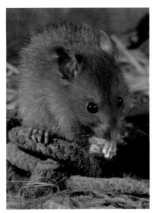

Size 16–24 cm, plus a tail of up to 26 cm.
Habitat Wide variety, usually close to man.
Food They are opportunistic, eating almost anything.
Range Widespread in C and S Europe; scattered populations in British Isles and N Europe.

Also known as the Ship or House Rat, it has largely been displaced by the Brown Rat (p.72), particularly in Britain and Scandinavia. Its colour varies, although it is usually blackish, with a long, bald tail. The ears are large and the muzzle rather pointed. It is usually active by night. The 3–5 litters a year each have up to 16 young.

Brown Rat

Rattus norvegicus

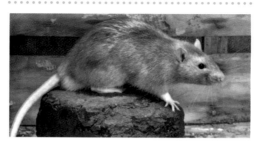

Size 20-28 cm, plus a tail of up to 23 cm.
Habitat Mainly around human settlements.
Food Almost anything.
Range Introduced by man from Asia, occurs throughout Europe, including islands.

The Brown Rat is usually brown above and greyer below, but there are wide variations. It makes extensive burrows, but is as much at home in water as on land, and may be confused with water voles when swimming. It is one of the most serious mammal pests, causing much damage, but it is also important prey for many other animals. It has up to 5 litters a year, of 7-15 young.

Wood Mouse

Apodemus sylvaticus

Size 7.5–11 cm, plus a tail of up to 11 cm.
Habitat Woodland, also gardens and hedgerows.
Food Seeds, fruit, plants and invertebrates.
Range Widespread across Europe, except far north.

The commonest mouse throughout much of
Europe and an important prey for many mammals
and birds. The upperparts are sandy-brown, and
the underside is silvery-white. It is extremely
agile and mainly active at night. It does not
hibernate, and in milder winters when food
supplies are good it will breed late into autumn.
It has up to 4 litters a year, of 3–9 young.

Yellow-necked Mouse

Apodemus flavicollis

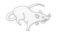

Size 8–13 cm, plus a tail of up to 13 cm.
Habitat Woodland, orchards, gardens and hedgerows.
Food Seeds, berries and fruits, and some insects.
Range Mainly E and C Europe, north to Scandinavia and Finland, west to France and N Spain.
Also S England and Wales.

Similar to the Wood Mouse (p.73), but slightly larger, it has lighter richer-brown fur above, and is paler underneath. There is always a yellowish-brown band of fur on the throat. It burrows less than the Wood Mouse and often enters houses. Up to 3 litters are born each year, of 2–9 young.

Harvest Mouse

Micromys minutus

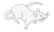

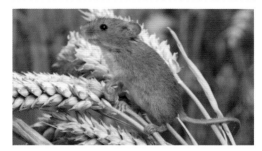

Size 50-80 mm, plus a tail of up to 75 mm.
Habitat Meadows, hedgerows, reedbeds and agricultural land.
Food Seeds, berries, shoots and buds; also insects.
Range Widespread in Europe. Absent from higher altitudes and most of the Mediterranean.

The smallest European rodent. It is sandy or reddish brown above and whitish below. It is extremely agile, using its partially prehensile tail to move quickly through tall vegetation. The nest is a spherical ball of woven grasses. It has several litters a year, of up to 6 young.

Western House Mouse

Mus domesticus

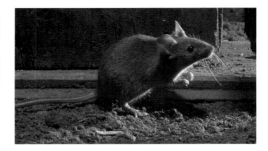

Size 75–95 mm, plus a tail of up to 95 mm.
Habitat Usually associated with human
habitation.
Food Seeds and grain; scavenges on human waste.
Range Common across W Europe, as far east as
Denmark and the Adriatic.

Brownish-grey above and paler below, the House
Mouse is common around human habitations in
both rural and urban areas. Mainly active at
night, it is an agile climber and it runs in straight
lines. Up to 10 litters are born each year, of up to
9 naked and helpless young.

Northern Birch Mouse

Sicista betulina

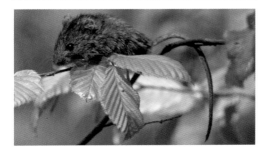

Size 50–78 mm, plus a tail of up to 10.5 cm.
Habitat Dense vegetation in woodland and meadows.
Food Small insects with some seeds and berries.
Range Patchy distribution from Scandinavia,
to W Russia, south through to C Europe.

The yellowish-brown fur of this mouse has a
conspicuous dark stripe running from the head
to the base of the long, partially prehensile, tail.
It is active by night, spending the daytime in
burrows and foraging at night; its high-pitched
whistle is distinctive. A single litter of 2–11 young
is born in the summer.

Tracks and Signs II

Rat

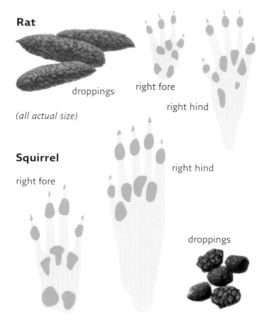

droppings

right fore

right hind

(all actual size)

Squirrel

right fore

right hind

droppings

78

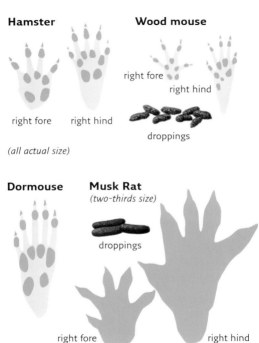

Hamster

right fore

right hind

Wood mouse

right fore

right hind

droppings

(all actual size)

Dormouse

right fore

Musk Rat
(two-thirds size)

droppings

right hind

Primates

The only primate that is native to Europe is the human species, *Homo sapiens*. The Barbary Ape was introduced from North Africa into Gibraltar where, although it lives in the wild, the population is artificially maintained.

The primates consist of lemurs, bush babies, monkeys and true apes. The latter are the tailless apes – the gorillas, Orang-Utan, chimpanzees and humans. The Barbary Ape is not a true ape, but an Old World Monkey, a macaque, although it lacks a tail. Like many other monkeys they have a well-developed social structure.

Barbary Ape

Macaca sylvanus

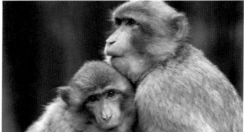

Size 60-70 cm, with no tail.
Habitat Rocky hillsides, with scrub.
Food Mainly vegetation, but they are fed regularly to discourage them going nearer the town.
Range Rock of Gibraltar, and numbering under 50.

The only primate found in Europe (apart from humans), it was introduced into Gibraltar from North Africa. In common with most monkeys, its muzzle is short, the eyes relatively large and the ears short; it does not have a tail. One young is born every other year, and they have been known to live for over 15 years.

Carnivores

Carnivores are extremely diverse in appearance, ranging from the mouse-sized Weasel to the Polar Bear. They are mostly predators, with teeth adapted for killing their prey, and for tearing meat; in particular, most have well-developed canine teeth. They also have thick fur, which in several species has led to them being extensively hunted, and some are bred on fur farms. Many species have been persecuted because of their predation on livestock, and most of the larger species are extinct over much of Europe, only surviving in the more remote areas or in parks and reserves. The young of carnivores are usually born blind and helpless, and are often very playful while growing up, staying with the mother while they learn to hunt. Several species take a large proportion of invertebrate food, and they may also feed on fruits and carrion (i.e. they may be omnivorous, meaning they feed on both animals and plants). They are generally shy and their presence is often only detected by their footprints, remains of prey and other signs.

Polar Bear
Ursus maritimus

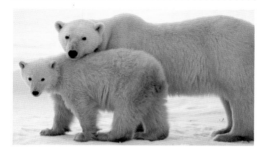

Size 1.6–2.5 m, plus a tail of up to 10 cm.
Habitat Floating ice and polar regions.
Food Seals, walruses, whale calves and fishes;
also carrion, plus lichens and moss.
Range Northern Polar regions.

The largest of the bears, the Polar Bear can weigh
up to 750 kg. It is mainly aquatic, living among
ice floes, and is an exceptionally strong swimmer.
It spends the winter in a den, and the single
young (or twins) is tiny at birth (no bigger than a
rabbit) and does not leave the den for 4 months.
It has lived to over 30 years in captivity.

Brown Bear
Ursus arctos

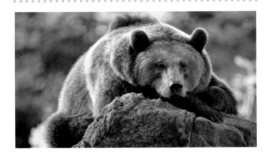

Size Up to 2 m, with no tail.
Habitat Forest, woodland and tundra.
Food A variety of plants, berries, fruit and fungus; also carrion, fish, insects, honey; occasionally livestock.
Range More remote mountains of Spain, Italy, France, Scandinavia and E Europe.

The Brown Bear once occurred over most of the northern hemisphere, but is now reduced to isolated populations. It varies from pale brown to black. It is mainly active by night, and hibernates in dens. The young (usually twins) are looked after by their mother until the following year.

Wild Animals

Wolf

Canis lupus

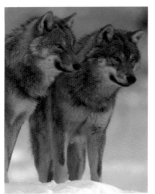

Size 1–1.6 m, plus a tail of up to 50 cm.
Habitat Open woodland and tundra, also forest.
Food Mostly mammals, up to the size of deer; also fruit.
Range Only small isolated populations survive, in Norway, Sweden, Italy, Spain and E Europe.

The Wolf is a powerful and intelligent animal. In the north of its range it tends to be more heavily built and more thickly furred. It lives in family groups, and the young (up to 5 in a litter) stay with the parents for up to a year; the male brings food for his mate and cubs. Although predators of livestock, wolves do not normally attack humans.

Jackal
Canis aureus

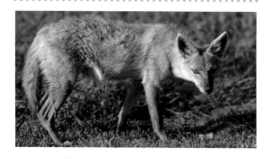

Size 71–85 cm, plus a tail of up to 30 cm.
Habitat Grassland and cultivated land, usually around human settlements.
Food Rodents, birds and carrion; frequently scavenges. Will raid domestic livestock.
Range SE Europe from NE Italy and Austria southwards.

A slender, long-legged dog, much lighter in build than the Wolf (p.85), and more reddish in colour. Mainly active at night, it generally hunts alone, but will occasionally form small packs. It is extremely vocal. The single annual litter is usually born in a burrow, and has 3–9 cubs.

Red Fox
Vulpes vulpes

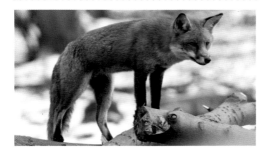

Size 60–90 cm, plus a tail of up to 60 cm.
Habitat Almost all habitats providing cover.
Has adapted well to urban areas.
Food Mainly small mammals; also fruit and poultry.
Range Widespread throughout Europe.

Rich brownish-red above and white below, the
Red Fox is dog-like in appearance with pointed
ears, a narrow muzzle and a bushy, white-tipped
tail. The back of the ears and paws are often
blackish. It is mainly active at night and does not
hibernate. The single annual litter has 3–8 cubs,
which are born in an underground earth.

Arctic Fox

Alopex lagopus

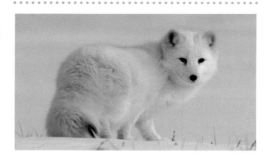

Size 50–85 cm, plus a tail of up to 55 cm.
Habitat Tundra and forest.
Food Small mammals, birds and fruit; also scavenges.
Range Widespread in the Arctic, also on many northern islands including Iceland.

The Arctic Fox has a short muzzle and rounded ears, and occurs in two distinct colour phases: some animals are pure white in winter and brownish in summer, others are bluish-grey in winter and darker grey in summer. It is active by day and night and makes extensive burrows. Up to 2 litters are born each year, of up to 21 young (more usually 7–10).

Raccoon Dog

Nyctereutes procyonoides

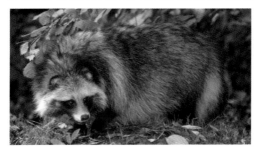

Size 50–80 cm, plus a tail of up to 26 cm.
Habitat Variable, usually in wooded areas, near water.
Food Rodents, amphibians, fruit and vegetable matter.
Range E France and Sweden, spreading eastwards.

About the size of the Red Fox (p.87), the Raccoon Dog was introduced into Europe from the Far East. It was bred on fur farms in the then USSR and escaped animals became established. It has a shaggy coat and short bob-tail, with a raccoon-like face mask. It has 1 litter a year, of 5–8 (sometimes up to 19) blind and helpless young.

Stoat

Mustela erminea

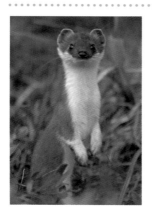

Size 17.5–30 cm, plus a tail of up to 14 cm.
Habitat Wide variety, usually with woodland.
Food Small mammals; also birds and eggs.
Range Across most of Europe, except the Mediterranean.

The Stoat's fur is reddish-brown above and creamy-white below; the tail is black-tipped. In the northern parts of its range it turns white in winter, except for the black-tipped tail. It is active by day and night, and makes a variety of squeaking and hissing noises as it hunts. One litter is born each year, of up to 12 helpless young.

Weasel

Mustela nivalis

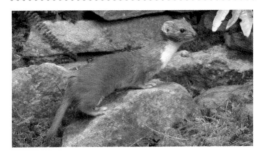

Size 11–26 cm, plus a tail of up to 87 mm.
Habitat Wide variety, usually with woodland.
Food Small mammals, mostly voles and mice.
Range Across Europe, except Ireland, Iceland and a few other islands.

This is the smallest European carnivore, which is very variable in size. It differs from the Stoat (p.90) in having a shorter tail without the black tip. It hunts on its own, by day or night, frequently standing on its hind legs to look around. The 1–2 litters a year each have 4–6 young (can be up to 12), which are born with pale, downy fur at birth.

American Mink

Mustela vison

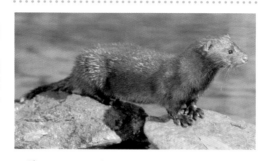

Size 31–45 cm, plus a tail of up to 25 cm.
Habitat Wide variety, usually near water.
Food Wide variety, including fish, mammals,
amphibians, invertebrates and birds.
Range Scandinavia to Russia; spreading over England.

Larger than the European Mink, the American Mink
was introduced into European fur farms. It is now
widespread in the wild as a result of escapes,
and considered a pest in many areas. Generally
lighter in colour than the European species, it is
very variable and has less white on its muzzle.
The single litter (of up to 6) is born in early summer.

Western Polecat
Mustela putorius

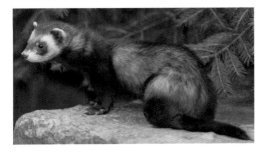

Size 34–47 cm, plus a tail of up to 19 cm.
Habitat woodland, often close to human habitation.
Food Small mammals, birds and invertebrates.
Range Occurs in Wales, but extinct across most of Britain. Widespread across most of rest of Europe.

The Polecat is similar in size, and closely related, to the domestic ferret. It has a characteristic facial mask, long neck, small head and short legs. The creamy-yellow underfur shows through the longer, dark brown guard hairs. It is mainly active by night and is very vocal, making a wide variety of noises. One litter of 2–12 young is born each year.

Pine Marten
Martes martes

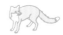

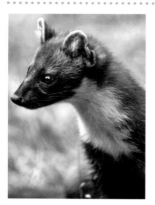

Size 35–58 cm, plus a tail of up to 28 cm.
Habitat Woodland and forest.
Food Birds and small mammals; also berries and fruit.
Range Most of Europe, except much of England, Spain, Portugal and Greece. Also on some islands.

The Pine Marten is rich brown in colour, except for its irregularly shaped yellowish throat patch; the tail is long and bushy. Although generally active by night, it often emerges at dusk and dawn. It is an agile climber, and on land runs with a bounding gait. The single litter of 2–7 (usually 3) is born in spring, and the young are covered with pale fur.

Beech Marten

Martes foina

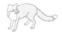

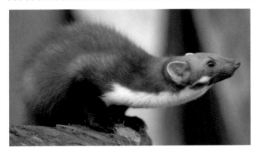

Size 44–54 cm, plus a tail of up to 32 cm.
Habitat Woodland, scrub and rocky hillsides.
Food Mainly small mammals and birds.
Range Widespread across most of Europe,
except British Isles and N Scandinavia.

Similar in size and colour to the Pine Marten
(p.94), the Beech Marten has a white (rather
than yellow) throat patch. Also known as the Stone
Marten, it is often found in arid, rocky areas where it
excavates short burrows. It is mainly active morning
and evening, but will emerge during the day.
The single litter of 1–8 young is born in spring.

Otter
Lutra lutra

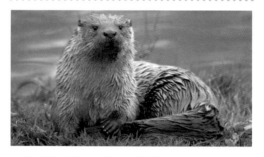

Size Up to 84 cm, plus a tail of up to 47 cm.
Habitat Wetlands, rivers and coastal areas.
Food Mainly fish, and aquatic animals including frogs.
Range Once throughout Europe. Extinct over much of its former range, but now expanding with protection in Britain.

The Otter's glossy fur is water-resistant, the body streamlined and the feet webbed. Normally active by night, it makes a variety of whistles and squeaks. It nests in a burrow (holt), and has 1 litter a year of 1–5 young, which, although furred, are helpless and blind at birth.

Badger
Meles meles

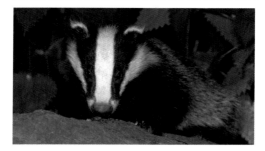

Size 67–87 cm, plus a tail of up to 19 cm.
Habitat Woodland and pasture, also scrub.
Food Omnivorous; earthworms main part of diet.
Range Extinct over most of Europe. Being reintroduced in some areas.

The Badger has a heavily built body with a long snout, the fur is grey above, black below and the face is striped black and white. It lives in a burrow (sett) which has many chambers and several entrances. Although it does not hibernate, it stays in its sett during cold weather. The single litter of 1–5 young is born in winter or early spring.

Raccoon

Procyon lotor

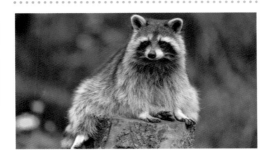

Size 60–95 cm, plus a tail of up to 40 cm.
Habitat Well-wooded country, often near water.
Food Wide variety, including molluscs, fish, frogs, small mammals, birds and their eggs, fruit and nuts.
Range Common to Germany and the Baltic states.

The Raccoon was introduced into Europe as a result of escapes from fur farms. The body fur is thick and grey, the tail bushy and striped, and the face has a distinctive 'robber's mask'. It is mainly active at night and does not hibernate. Despite its rather ungainly appearance it swims and climbs well. One litter of 1–7 young is born in spring.

Lynx
Lynx Lynx

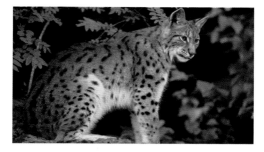

Size 70–150 cm, plus a tail of 12–24 cm.
Habitat Forest, rocky slopes and scrub.
Food Mammals up to the size of young deer and birds.
Range Extinct over much of Europe, except Scandinavia and E Europe.

This large cat has long legs, distinctive ear tufts and a stumpy, black-tipped tail. It is usually sandy coloured with variable spotting, the most heavily spotted animals occurring in the Carpathians, Eastern Europe. It is usually solitary and hunts mainly at night. The single litter is born in early summer and contains 1–4 young.

Genet

Genetta genetta

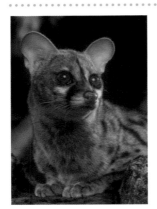

Size 44–55 cm, plus a tail of up to 48 cm.
Habitat Woodland, scrub and open, well-vegetated areas.
Food Birds and small mammals, also fruit and berries.
Range Widespread across Spain and Portugal, north into France, where it is expanding its range. Also occurs on Mallorca.

This cat-like carnivore is about the same size as a domestic cat, but has a longer, banded tail and shorter legs; the fur is sandy-yellow and heavily spotted. It was introduced into Europe from North Africa. It is shy and elusive, making its lair in a hollow tree, rock cleft or among roots, and hunting at night. The single litter has 1–3 young.

Wild Cat
Felis sylvestris

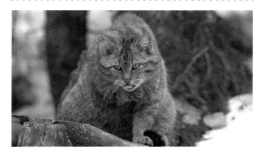

Size 46–78 cm, plus a tail of up to 38 cm.
Habitat Forest and woodland; rocky and scrub habitats in the south of its range.
Food Up to lamb-sized mammals, birds and carrion.
Range Patchily distributed throughout N Europe.

Larger than domestic cats, the Wild Cat has a proportionally bushier and blunter tail; it has 'tabby' markings. Mainly nocturnal, it is a good climber, but mostly hunts on the ground. It does not hibernate and usually has 1 litter, though it may have up to 3. The 1–8 young are born blind and helpless.

Tracks and Signs III

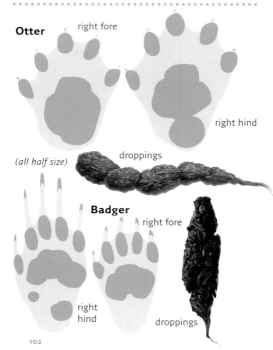

Otter

right fore

right hind

(all half size)

droppings

Badger

right fore

right hind

right fore

droppings

102

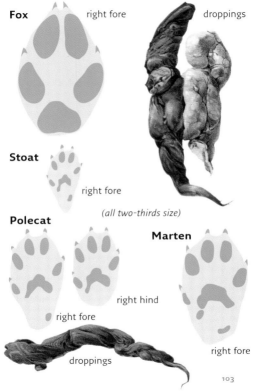

Fox right fore

droppings

Stoat

right fore

(all two-thirds size)

Polecat

right hind

right fore

droppings

Marten

right fore

Seals and Walrus

Seals are highly specialised marine mammals classified with the carnivores. There are three groups: the sealions and fur seals (which do not occur in European waters), the Walrus, and the seals. Unlike the whales and dolphins (cetaceans), the seals need to come to land in order to give birth. In some cases the pup is able to swim within a few hours of birth, but most are confined to land for several weeks. Seals often haul out and bask in the sun on undisturbed shores. While on land seals are awkward and can only move with difficulty, but once in water they are extremely agile. The Walrus, and several species of seal, breed on ice floes in the Arctic. They mostly have a single pup, often with a thick white fur that is moulted before it takes to the sea. The only seal to occur in the warmer waters of the Mediterranean is the Monk Seal, which is seriously endangered. It seems unlikely that it will survive because, in addition to persecution by fishermen, it is suffering from the effects of increased pollution, and being trapped in drifting fishing gear.

Common Seal
Phoca vitulina

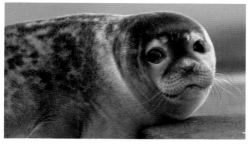

Size 1.2–1.6 m.
Habitat Inshore waters, including sea lochs and occasionally rivers.
Food Mainly fish, also shellfish and crustaceans.
Range Breeds around the British Isles, N France and north to Arctic Scandinavia and Iceland.

This small seal has a concave muzzle and variable colouring, which is usually greyish with dense mottling; the whiskers are white. A single pup is born each year (in midsummer) on a beach or sand bar, and is suckled in the sea; they are active from birth.

Grey Seal
Halichoerus grypus

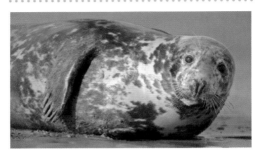

Size 1.65–2.3 m.
Habitat Marine, but breeds on shore.
Food Fish and crustaceans.
Range Around coasts of the British Isles, N France, the Baltic, Scandinavia, Russia and Iceland.

The Grey Seal has a dog-like head and a convex profile. The male is larger and dark with light blotches; the female is paler with dark blotches. Large colonies congregate to breed and are very vocal, wailing and barking. The single pup is born on shore and has whitish, silky fur.

Harp Seal
Pagophilus groenlandicus

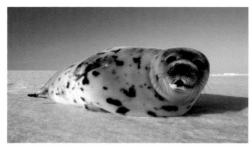

Size 1.8–2 m.
Habitat Marine; rarely in waters south of 60° N.
Food Mostly fish.
Range Breeds in N Scandinavia and Russia. Occasionally as far south as Britain and W Sweden.

The male Harp Seal is creamy-white with a blackish head and a characteristic darker marking, which is 'harp' shaped, across the back. The female's markings are less distinct. They congregate in large groups during the breeding season, when a single pup is born on the ice. It has thick yellowish fur and is active from birth.

Hooded Seal
Cystophora cristata

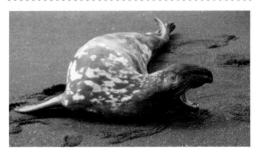

Size 1.8–2.5 m.
Habitat Marine.
Food Fish and squid.
Range Breeds on Jan Mayan, near Spitzbergen, and disperses south, occasionally as far as Britain.
Similar species Often found with Harp Seals (p.107).

The Hooded Seal is large and greyish with variable paler markings; the female is generally lighter in colour. The male has a crest on the nose which it can inflate to form a large hood. A single pup is born each spring with white fur, which moults into bluish-grey soon after birth.

Walrus
Odobenus rosmarus

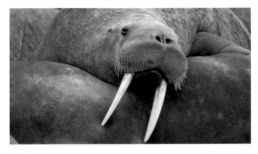

Size Up to 2.5 m.
Habitat Marine, close to Arctic ice.
Food Bivalve molluscs, and occasionally seals.
Range Patchy distribution in North Atlantic and Arctic Oceans; occasionally south to Iceland, Norway.

The Walrus is the largest seal in European waters. The male (also some females) is distinguished by its large (up to 1 m) tusks; it also has a 'moustache' of bristles on the snout. The greyish skin is thick and wrinkled. They congregate in large herds on the ice to breed, and pups can swim within a few hours of birth.

Hoofed Mammals

There are two groups of ungulates, or hoofed mammals: the odd-toed (horses, rhinos and tapirs), and the even-toed (pigs, cattle, sheep, deer and their relatives). Only the latter occur in a truly wild state in Europe. Ungulates are generally large, and they are all herbivorous, either grazing or browsing vegetation. Most of them have horns, which are used by the males for fighting in the breeding season (rut). They are mostly gregarious, living in herds or flocks, and the young are active from birth, often joining the herd within a few hours of birth. Nearly all the species are hunted, and in some cases they owe their survival to this fact. The earliest wildlife protection laws were usually concerned with protecting deer, bison and other ungulates, in order that they could be hunted. In areas where they are protected they are often relatively easily seen, but elsewhere they are often shy and active by night.

Wild Boar

Sus scrofa

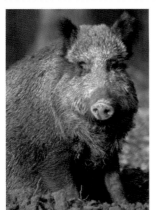

Size 1.1–1.8 m, plus a tail of up to 25 cm.
Habitat Forest, woodland and farmland.
Food Omnivorous.
Range Widespread over most of Europe, north to S Scandinavia. Extinct in British Isles. Feral wild boar escaped from farms in 1987 are now spreading in England.

The Wild Boar is the ancestor of the domestic pig, and, although extinct or rare over much of Europe, it has been successfully protected and reintroduced as a game animal in many areas. The adult is covered with coarse, dark brown hair, and has prominent tusks; the young have pale longitudinal stripes.

Bison

Bison bonasus

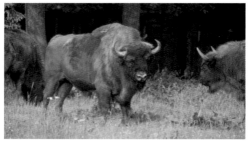

Size 2.5–3.5 m, plus a tail of up to 80 cm.
Habitat Forest and woodland.
Food Leaves, twigs and other vegetation.
Range The Bialowieza Forest in Poland and a few other reserves in Russia and other parts of Europe.

The largest European land animal, the Bison has humped shoulders, curving horns and dark brown fur. Once widespread, it became extinct in the wild in the early 20th century, but has been reintroduced. It lives in herds, which are mainly active by day, but it often feeds at dusk and dawn. A single calf is born every other year.

Mouflon

Ovis musimon

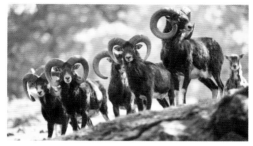

Size 80 cm–1.25 m, plus a tail of up to 15 cm.
Habitat Deciduous and mixed woodland,
and mountain grassland.
Food Herbs and grasses.
Range Corsica and Sardinia; successfully introduced
into many other parts of mainland Europe.

Although an ancestor of the domestic sheep,
the Mouflon lacks the woolly fleece. It is dark
above, paler below and the male usually has a
paler patch on the flanks (saddle) and heavy,
curled horns. It is mainly active by day; in winter
it may descend to lower altitudes.

Feral Goat
Capra hircus

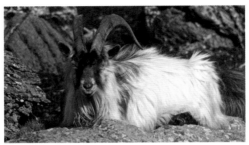

Size About 1.5 m, plus a tail of up to 20 cm.
Habitat Rocky hillsides in the Mediterranean;
upland and moorland in British Isles.
Food A wide range of vegetation.
Range Main populations in British Isles and around
the Mediterranean, particularly on Greek islands.

Feral Goats vary enormously in appearance.
Those in the British Isles are generally long-haired,
and often black and white. Their horns twist
outwards (not backwards, as in the wild goats).
In behaviour and breeding they are very similar to
the wild species, and are often very shy and elusive.

Chamois
Rupicapra rupicapra

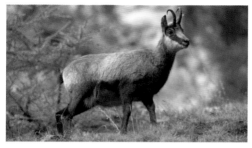

Size 90–140 cm, plus a tail of up to 8 cm.
Habitat High summer pastures; valleys in winter.
Food Grasses and herbs, also browses on trees.
Range Isolated populations, sometimes considered
separate species, from N Spain through France, Italy
and C Europe to the Balkans.

The fur of the Chamois is light brown in summer,
turning almost black in winter; the face is black and
white. Both sexes carry slender horns, which curve
sharply backwards at the ends. They form large
herds in the winter. A single lamb, occasionally
twins or triplets, is born in the summer.

Red Deer
Cervus elaphus

Wild Animals

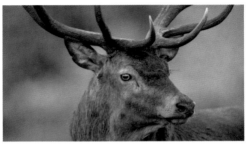

Size 1.7–2.6 m, plus a tail of up to 15 cm.
Habitat Forest, woodland; also more open habitats.
Food Grasses, shoots, twigs, leaves and bark.
Range Widespread over much of Europe, from Spain and Portugal to Scandinavia.

Variable in size and colouring, the Red Deer is usually reddish-brown in summer and more greyish in winter; fawns are heavily spotted. The male has large, branching antlers and develops a shaggy mane during the rut, when its loud roars can be heard. It is mainly active by night (sometimes by day), and often lives close to humans.

Fallow Deer
Dama dama

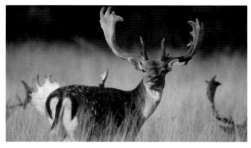

Size 1.3–2.4 m, plus a tail of up to 20 cm.
Habitat Parkland and open woodland.
Food Grasses, leaves and shoots.
Range Partly domesticated, occurs widely across
Europe, both in the wild and parkland.

The Fallow Deer varies widely from buff-brown
with whitish spots on the back to a more
uniform white to blackish colour. The male's
antlers are thick and flattened (palmate), and the
tail is longish with a black line down the centre.
They live in herds and produce 1 (occasionally 2)
heavily spotted fawns a year.

White-tailed Deer
Odocoileus virginianus

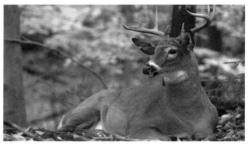

Size 1.3–2 m, plus a tail of up to 33 cm.
Habitat Woodland.
Food Grasses, twigs, leaves and shoots.
Range An American species, introduced into
Finland, Czech Republic and former Yugoslavia.

This deer is reddish-brown in summer and
greyish-brown in winter. The tail is thick and bushy,
and white below; when alarmed, it flicks it,
exposing the white on the tail and white rump.
The male's antlers are wide and curve inwards at
the tips. A single fawn is born in the summer,
with maybe a litter of 2–3 in the second year.

Elk

Alces alces

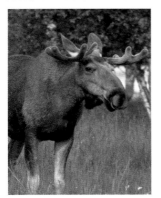

Size 2–3.1 m, plus a tail of about 5 cm.
Habitat Wet woodland and swamps.
Food Browses on trees; also aquatic vegetation.
Range Widespread in Scandinavia, around the Baltic to Poland, spreading southwards.

This large deer, known as the Moose in North America, has a dark brown body with pale legs. The male carries broad, flattened (palmate) antlers and will fight for females during the rut. They are solitary or live in small family groups and are agile on land or in water. The young (usually 2, but can be up to 4) are born in early summer.

Reindeer
Rangifer tarandus

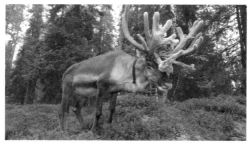

Size 1.7–2.2 m, plus a tail of up to 18 cm.
Habitat Arctic tundra and woodland.
Food Lichens, shoots, grasses, sedges and leaves.
Range Reduced to small populations in
Scandinavia and eastwards through Russia.

The Reindeer is greyish to greyish-white, and both
sexes carry antlers, which have a forward sweeping
branch and, unlike any other deer, have a second
branch near the top. They are active by day and
night and often form large herds. The single calf
is born in spring and is active soon after birth.
Reindeer have been domesticated on a large scale.

Roe Deer

Capreolus capreolus

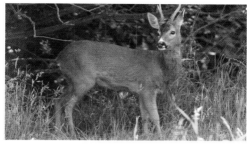

Size 90–130 cm, plus a tail of up to 3.5 cm.
Habitat Woodland and forest.
Food Grasses, shoots and leaves.
Range Widespread across Europe, including parts of Great Britain, but absent from most islands.

The smallest native European deer, the Roe Deer is rich reddish-brown, turning greyer in winter. The male carries short, spiky antlers; both sexes have a barking call. Although usually active by night, when not disturbed they are also active by day. The single litter has up to 3 fawns (usually 2), which are heavily spotted.

Reeves' Muntjac
Muntiacus reevesi

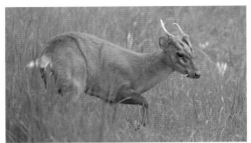

Size 70–90 cm, plus a tail of up to 12 cm.
Habitat Woodland and gardens, often suburban.
Food Wide variety of vegetation, including shoots, grasses and leaves; also garden plants and fruit.
Range Widespread and abundant in S and E England.

This small, stocky deer was introduced into England from Asia, as a result of escapes from wildlife parks. Uniformly mid- to dark brown, the broad tail conceals a white rump, which is only visible when it runs away. The male has short antlers and small tusks. It is also known as the Barking Deer, as it emits a dog-like bark loudly and repeatedly.

Chinese Water Deer

Hydropotes inermis

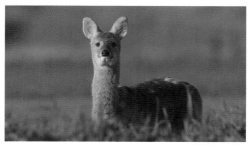

Size 75–105 cm, plus a tail of up to 8 cm.
Habitat Marshes, woodland and parkland.
Food Shoots, leaves and grass.
Range Introduced and spreading in S and E England and one locality in France, from wildlife park escapes.

Generally a uniform sandy-brown, this is the only deer in Europe that lacks antlers in both sexes; the male, however, has quite prominent tusks. It is mainly active by night. The male has a whistling call during the rut, and it 'screams' when alarmed. The single litter is born in late spring, with up to 6 (usually 2–4) spotted fawns.

Tracks and Signs IV

Red Deer

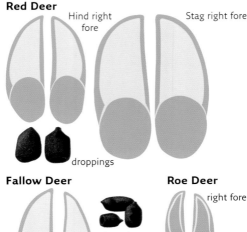

Hind right fore

Stag right fore

droppings

Fallow Deer

droppings

Stag right fore

(all half size)

Roe Deer

right fore

droppings

Chamois

right fore

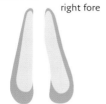

Mouflon

right fore

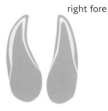

(all half size)

Elk

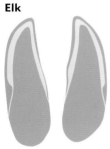

right fore

Reindeer

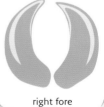

right fore

Whales and Dolphins

There are two groups of cetaceans: the toothed whales (including the dolphins and porpoises) and the baleen whales. The latter lack teeth and feed by filtering fish and plankton through horny plates of baleen. The baleen whales are all large, and include the largest mammal known, the Blue Whale, which grows to a length of 33 m, and weight of 190,000 kg. The largest of the toothed whales is the Sperm Whale. Cetaceans are all entirely aquatic, even giving birth at sea. Some dolphins are gregarious, and may live in schools numbering several hundred. The toothed whales use sonar (similar to bats) to navigate and hunt their prey. Some of the baleen whales use 'songs' to communicate over many kilometres. The larger species (and some of the smaller) have been hunted to the brink of extinction, and thousands are killed in nets set for tuna and other fish. Humpback Whales are often seen jumping clear of the water, and even somersaulting. In the middle of their back cetaceans often have a boneless fin, called the dorsal fin.

Fin Whale
Balaenoptera physalus

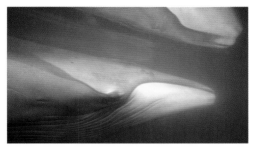

Size Up to 26.8 m.
Habitat Marine.
Food Small fish and plankton.
Range Formerly widespread in European waters.
Now mostly seen off the Hebrides, Iceland and Norway.

The Fin Whale (or Common Rorqual) is unusual in having asymmetrical colouring – the right side of the lower jaw is pale, the left is dark. It is large and slender with a small dorsal fin. It travels singly or in pods (groups) of up to 15, and moves to tropical waters in the winter. A single young is born every other year.

Sperm Whale
Physeter catodon

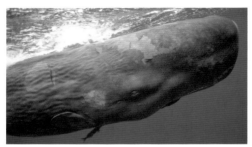

Size Up to 20 m, usually 11–15 m.
Habitat Marine.
Food Squid and octopus, also some fish.
Range Only in European waters (particularly the Mediterranean) and, in summer, north to the Arctic.

The Sperm Whale is the largest toothed whale, having peg-like teeth on the lower jaw only. It has a large, square-shaped head, and broad, triangular tail flukes. Its social structure is such that when one is injured, or a female is giving birth, others will come to help. A single calf (occasionally twins) is born every 4 years, in winter.

Killer Whale
Orcinus orca

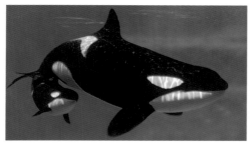

Size Up to 9.75 m.
Habitat Marine.
Food Sea mammals, including whales and seals; also birds, fish and squid.
Range Widespread in Atlantic Ocean, North and Baltic Seas and Mediterranean.

The Killer Whale, or Orca, has a large, triangular dorsal fin (up to 2 m high), which can be seen cutting through the water as it swims close to the surface. It has distinctive black and white markings, and is carnivorous with long, conical teeth. It travels in pods of up to 20 and will prey on other whales.

Bottle-nosed Dolphin

Tursiops truncatus

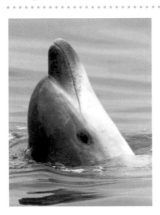

Size Up to 4 m.
Habitat Marine.
Food Fish and
crustaceans.
Range Common
and widespread in
Atlantic and
Mediterranean.
Also occurs in
other European
seas.

Wild Animals

These dolphins are bluish-grey above and paler
below, with spotted flanks. The dorsal fin is tall
and slender, and the beak is short, but promi-
nent. Although relatively slow swimmers, they
are playful and gregarious. They are mainly
marine, but can occur in lagoons, bays and
rivers. This is the species most often exhibited
in aquariums.

Common Dolphin

Delphinus delphis

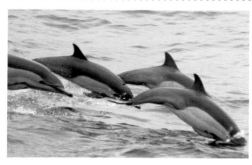

Size Up to 2.6 m.
Habitat Marine.
Food Squid and fish.
Range Widespread in all European seas.

The Common Dolphin is tri-coloured: dark grey above, white below, with bands of paler grey and yellowish-fawn on the sides; the eye patch is usually black. Schools of up to 250,000 were once recorded, but numbers have declined considerably. A single calf is born every 2–3 years, and they can live to over 30 years.

AMPHIBIANS
Salamanders and Newts

The tailed amphibians are all long-bodied, and usually have moist skins. The term 'salamander' is used to indicate the largely terrestrial species, while 'newt' is confined to those that spend much of the year in water. Unlike salamanders, male newts have crests during the breeding season, which range from single ridges to long, flowing crests, and are used in elaborate courtship displays. Most species are active at night, and are more easily observed with a torch, on warm summer evenings after heavy rain.

Most newts and salamanders lay eggs, though some retain the eggs within the body until they are ready to hatch, or even produce fully metamorphosed young. (The change from the larval 'tadpole' to the adult is known as metamorphosis.) The tadpoles are distinguished from those of frogs and toads by their feathery external gills, and the forelegs develop much earlier. Some species are neotenous – that is, they retain the characteristics of the juveniles throughout their life.

Fire Salamander
Salamandra salamandra

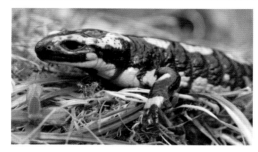

Size Up to 20 cm, including tail.
Habitat Usually damp, forested areas close to water.
Food Slow-moving invertebrates such as worms and molluscs; also small amphibians.
Range Widespread over most of Europe, except north and east; absent from British Isles.

The Fire Salamander is black with varying amounts of yellow, orange or reddish markings; it is sometimes striped. Mainly active at night, it is normally only seen after rain. The tadpoles are born well developed, sometimes fully metamorphosed.

Alpine Salamander

Salamandra atra

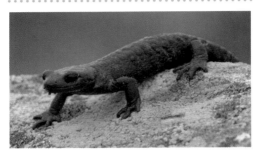

Size Up to 16 cm, including tail.
Habitat Usually in wooded, mountainous habitats, mostly between 800–2,000 m, but up to 3,000 m.
Food Invertebrates.
Range The Alps, east to the former Yugoslavia and Albania.

A uniformly black salamander, usually active and visible after rain at night; at other times it hides under logs and rocks. Because of the short summers in its habitat, the young (usually 2–4) are born fully metamorphosed, but may take up to 4 years to develop inside the mother.

Sharp-ribbed Salamander

Pleurodeles waltl

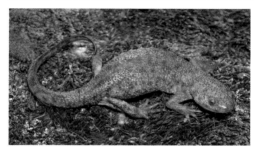

Size Up to 30 cm, including tail.
Habitat Normally in or close to water.
Food Invertebrates, and other small aquatic animals, including tadpoles.
Range Only in Spain and Portugal.

A large, rather heavily built, salamander. It has a row of orange warts along its side, and the ribs sometimes protrude through them. It is mostly active by night and aquatic, burrowing under stones in summer when the ponds and streams dry up. The male has pads on its forelegs during the breeding season.

Marbled Newt
Triturus marmoratus

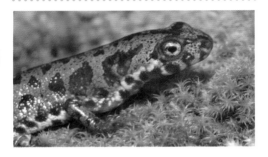

Size Up to 16 cm, including tail.
Habitat Always close to water for breeding, but often in relatively dry areas, including woodland and heaths.
Food Invertebrates.
Range Common only to Portugal, Spain and W France.

A beautifully coloured newt, with bright green markings on the back, which appears velvety outside the breeding season. The underside is greyish, and females and young have an orange stripe down the back. Like other newts, it is totally aquatic in the breeding season, and the breeding males have a striped crest.

Northern Crested Newt

Triturus cristatus

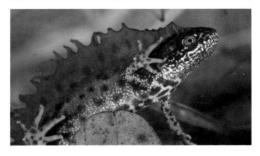

Size Up to 18 cm, but usually less.
Habitat Wide variety, usually close to water.
Breeds in deep ponds, or slow-flowing streams.
Food Invertebrates, eggs and young of amphibians.
Range Widespread over most of N Europe;
in Britain it has declined over many areas.

A large newt, generally found in or close to water.
It has a rather warty skin, which is usually black
above and bright yellow or orange, with black
markings, below. When breeding, the male is paler
above, with a large, jagged crest. In the south of
its range it is usually found at higher altitudes.

Salamanders and Newts (Caudata)

137

Alpine Newt
Triturus alpestris

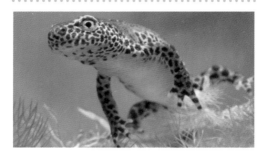

Size Up to 12 cm.
Habitat Always close to water; often aquatic all year.
Food Invertebrates, fish and amphibian eggs.
Range Widespread in C Europe. Isolated populations in Spain and former Yugoslavia. Introduced in Britain.

A medium-sized newt with a much wider distribution than its name suggests. It is dark above, often blackish when on land, with a bright, unspotted, orange belly. Some populations are neotenous (see p.132), retaining gills throughout their life. It is only found in mountains in the south of its range, but at sea level in the north.

Smooth Newt
Triturus vulgaris

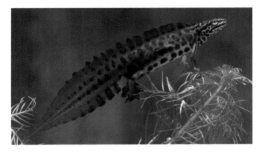

Size Up to 11 cm, but often much smaller.
Habitat Always close to breeding waters.
Food Invertebrates, fish fry and amphibian eggs.
Range Widespread over Europe, except the SW.

Generally the most widespread and abundant newt over most of its range. It is relatively small and the orange belly is usually spotted. In the breeding season the male develops a very large, wavy crest along the body and tail. It leaves the water after breeding, and the skin becomes dryish and velvety, and it may be confused with a lizard. They normally hide under logs and stones.

Palmate Newt

Triturus helveticus

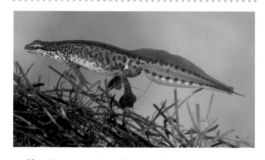

Wild Animals

Size Up to 9 cm, but often smaller.
Habitat Favours rather acid, clear water for breeding; sometimes even brackish water.
Food Invertebrates.
Range Confined to NW Europe.

A small newt, easily confused with the Smooth Newt (p.139) as their ranges mostly overlap. The Palmate Newt is generally slightly smaller, less spotted on the belly, and the breeding male has only a slight crest, confined to the tail. However, the male has distinctive blackish hind feet, and its tail ends in a filament.

Frogs and Toads

The name 'frog' is generally applied to the smooth-skinned species of amphibians, while the 'toad' has rough, warty skin. They are all short-bodied, lack tails and have significantly longer back legs than forelegs. Most of them jump, and some species are able to jump a metre or more. Some species have a paratoid gland, a large swollen area behind the eye, containing poisons. Some salamanders also have these glands. All frogs and toads except the Midwife Toads migrate to water during the breeding season, where they lay spawn in clumps, or long strings, which hatches into tadpoles. In a few species the tadpoles grow very large – larger even than the adults. The group of frogs known collectively as 'green frogs' are very aquatic, and their classification is extremely complex since it involves hybrid populations. These, and several other species, can be particularly difficult to identify, but during the breeding season the males have distinctive mating calls. These sounds are often amplified by inflatable vocal sacs – either a single one under the chin, or a pair either side of the head.

Yellow-bellied Toad

Bombina variegata

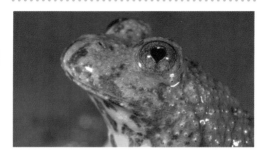

Size Up to 5 cm.
Habitat Usually around ponds and ditches, in well-vegetated areas, including woodland.
Food Mostly invertebrates.
Range Widespread from France to E Europe and N Italy.

A small, distinctive toad, which is often very abundant. It is distinguished from other species by its contrasting yellow and black underside. During the breeding season the male's voice is a musical *poop-poop-poop*, given in chorus with other males. It is active by day and night, and can often be seen swimming in its breeding pool.

Midwife Toad

Alytes obstetricans

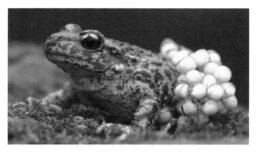

Size Up to 5 cm.
Habitat Woodland, gardens and hedgerows;
hides in burrows during the day.
Food Invertebrates.
Range W Europe; introduced into England.

This small toad has prominent eyes with a vertical
pupil (most frogs and toads have a horizontal pupil).
It is named for its breeding behaviour; the male
carries the spawn wrapped around its hind legs,
taking it to water to keep it moist and depositing
it in shallow water when the tadpoles are ready
to hatch. The call is a bell-like *poo-poo-poo*.

143

Common Spadefoot
Pelobates fuscus

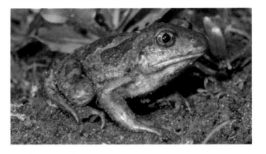

Size Up to 8 cm.
Habitat Cultivated areas, coastal dunes.
Food Invertebrates.
Range Widespread from France and C Europe eastwards to Siberia, but declining in many areas.

This toad is distinguished from the true toads by having a vertical pupil. The hind feet have 'spurs', which are used for digging burrows up to 1 m deep. It likes sandy soils suitable for digging, and when captured it exudes a strong smell of garlic. Breeding males make a repeated clicking sound. Fully grown tadpoles measure up to 18 cm.

Common Toad
Bufo bufo

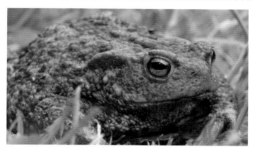

Size Up to 15 cm; larger in south of range.
Habitat Almost all habitats, except extreme cold.
Food Invertebrates, and other small animals.
Range All Europe, except Ireland and N Scandinavia.

A relatively large, robust species with an extremely warty skin and large paratoid glands. As with all true toads and frogs, the pupil is a horizontal slit in bright light. Its colour changes slightly to match its surroundings. During the breeding season males gather in shallow water, and have a rather soft call. The eggs are laid in long strings, usually wrapped around waterweed.

Natterjack
Bufo calamita

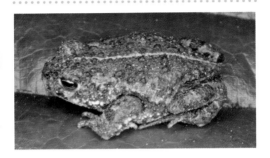

Size Up to 10 cm, but usually smaller in north of range.
Habitat Usually rather sandy areas, including dunes.
Food Invertebrates.
Range From Portugal and Spain east to the Baltic and S Sweden; also England and S Ireland.

A small, relatively short-limbed toad, that tends to run rather than hop. It is easily recognised by the thin yellow stripe down the middle of the back. Breeding males gather around breeding pools and their calls can be heard for 2 km or more. Each call is a rapid ratchet-like sound, but several hundred merge into a continuous sound.

Green Toad
Bufo viridis

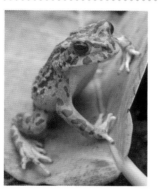

Size Up to 10 cm.
Habitat Usually relatively dry, lowland areas.
Food Invertebrates.
Range Widespread over E Europe, and as far west as NE France.

A heavily built toad with prominent paratoid glands (see p.141), and generally very attractively marked with green patches on a pale background. When breeding, the male has a high-pitched trilling call. Outside the breeding season, the Green Toad can often be seen hunting around lampposts and other artificial lights, which attract large numbers of moths and other flying insects.

Common Tree Frog

Hyla arborea

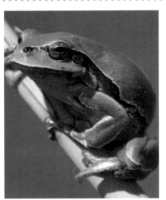

Size Up to 5 cm, but usually smaller.
Habitat Close to water, in reeds or bushes, where it climbs extensively.
Food Invertebrates.
Range Most of Europe, except the north, British Isles and southern Spain and Portugal.

A very small, brightly coloured frog, with pads on the ends of the fingers and toes. The back is usually brilliant green, but can be a blotchy brown or yellow. It is distinguished from other tree frogs by a dark, often cream-edged, stripe along the sides, from the eardrum to the hind leg. It often basks in full sun, relying on its colouring for camouflage.

Common Frog
Rana temporaria

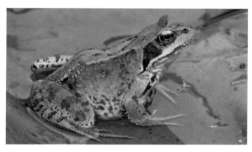

Size Up to 10 cm, but usually smaller.
Habitat Most places with suitable breeding waters.
Food Invertebrates.
Range Across Europe, except Spain and Portugal.

The Common Frog is one of the most widespread and abundant amphibians in Europe; it is extremely tolerant of the cold. Its colour varies, being yellowish, brown or reddish. Compared with other frogs, it has relatively short hind limbs, but is still a powerful jumper. When breeding, the male has black thumb pads for clasping the female. The call is rather quiet and produced under water.

Moor Frog
Rana arvalis

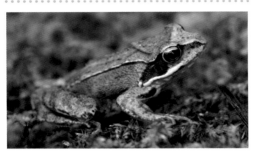

Size Up to 8 cm.
Habitat Meadows, moors and similar damp places.
Food Invertebrates.
Range N and E Europe.

Very similar to the Common Frog (p.149), the Moor Frog has proportionally shorter hind limbs. The snout is more pointed and it generally has a rather striped pattern. It is found in moorland habitats such as meadows, bogs and fens, but rarely occurs at high altitudes.

Agile Frog
Rana dalmatina

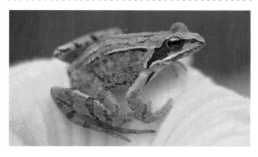

Size Up to 9 cm.
Habitat Wet meadows, woodland.
Food Invertebrates.
Range From France, east to Romania, and south to Italy and Greece.

A relatively slender, long-legged frog, the Agile Frog is usually a delicate brownish above and pale below. It is a powerful jumper, often taking to the water when alarmed or pursued. It is usually found close to water, in fairly damp habitats, where its colouring makes it look like dead leaves.

Iberian Marsh Frog

Rana perezi

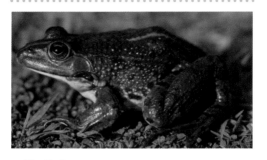

Size Up to 15 cm.
Habitat Always close to water, in marshes, slow-flowing rivers, reservoirs, etc.
Food Invertebrates, fish and other amphibians.
Range Common to Spain, Portugal and S France.

A large frog, usually with extensive amounts of green on its back. It is often seen basking in the sun, either floating at the water's edge, or on the bank within easy leaping distance of the water. The male's vocal sacs are on either side of the head and are easily seen. Its croak is a loud *croax, croax, brek, kek, kek*.

Wild Animals

Pool Frog
Rana lessonae

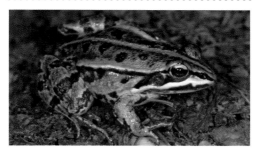

Size Usually 4–5 cm, sometimes larger.
Habitat Wide variety, but always close to water.
Food Invertebrates and other small animals.
Range France, east to Russia and S Sweden, and south to Italy and Sicily.

The smallest of the 'green' frogs, it is nearly always seen close to water, basking on lily pads, floating at the surface or on the water's edge within leaping distance of the water. It is often very noisy, with a call similar to that of the Iberian Marsh Frog (p.152).

Tortoises and Turtles

Worldwide, there are over 300 species of tortoises, terrapins and marine turtles. They all have a body which is enclosed in a shell or carapace. The shell is usually covered in hard, horny scales, but in some species it is enclosed in a tough skin. The term 'turtle' is confusing: in America it refers to all the species, whereas in Europe it is generally restricted to the marine species.

They all lay eggs, the sea turtles coming to sandy beaches in order to lay. The newly hatched young are miniature versions of the adults, but often more strikingly marked. All species have declined in recent years. The marine species are hunted for their meat and shells, and their eggs are gathered. They are also drowned in fishing gear, and some species swallow plastic bags in mistake for jellyfish. The land tortoises have been collected in their thousands for the pet trade, and they have also suffered from extensive forest fires in the Mediterranean areas.

Hermann's Tortoise

Testudo hermanni

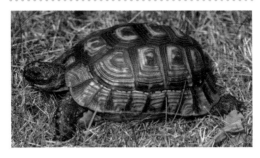

Size Shell is up to 20 cm long.
Habitat Areas with thick undergrowth.
Food Mostly vegetable matter, but also carrion.
Range Scattered populations, mainly in Italy and the Balkans.

This tortoise is distinguished from other species by having a large claw-like scale on the tip of its tail, and two plates on the edge of the shell above the tail. It lays round, white eggs with leathery shells; these are often dug up by mammals such as martens for food. They are also killed in forest fires, and have been collected as pets.

Spur-thighed Tortoise

Testudo graeca

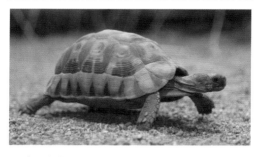

Size Shell is up to 25 cm long.
Habitat Areas with thick undergrowth.
Food Mostly vegetarian, but also scavenges carrion.
Range Confined to small populations in warmer parts of the Mediterranean.

Similar to Hermann's Tortoise (p.155), but the tail does not end in a claw, and there is only one plate on the edge of the shell above the tail. As its name suggests, it has spur-like scales on its thighs. Tortoises usually hide during the heat of the day, but can often be heard as they move slowly through undergrowth in the early morning or evening.

Eastern Stripe-necked Terrapin

Mauremys caspica

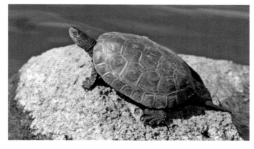

Size Shell is up to 20 cm long.
Habitat Always in or close to water.
Food Omnivorous, eating small animals and vegetable matter.
Range Greece, north to Bulgaria, and the Balkan coast.

A predominantly green-grey terrapin, with conspicuous stripes on the neck. The carapace is much flatter than that of tortoises. It often basks in the sun, and individuals may congregate close together by the water's edge. Hatchlings are more brightly marked than adults and have proportionally longer tails.

Loggerhead Turtle

Caretta caretta

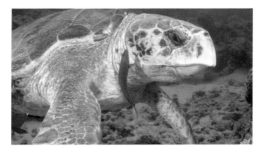

Size Up to 1 m, occasionally more.
Habitat Marine, coming to shore to nest.
Food Jellyfish, crustaceans and other animals.
Range Black Sea to Atlantic Ocean.

The species of turtle most likely to be encountered in European waters, it is often accidentally caught by fishermen in the Mediterranean. The numbers captured and killed, or drowned in fishing nets, are probably a serious threat to the survival of the species. It returns to (mostly Mediterranean) sandy beaches to nest, and these sites are increasingly threatened by resort developments.

Luth Turtle
Dermochelys coriacea

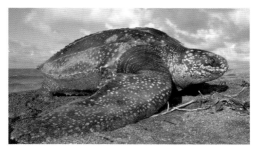

Size Up to 1.8 m, and weighing up to 500 kg.
Habitat The open sea, coming to beaches to nest.
Food Jellyfish and other animals.
Range Atlantic Ocean and Mediterranean Sea.

The Luth (or Leatherback) Turtle is very large, with five or seven ridges running the length of its carapace. It often occurs far out at sea, and is a regular migrant to Atlantic waters, probably coming from the American side of the Atlantic. It has been shown to be able to regulate its body temperature. It nests mostly on Mediterranean, sandy beaches laying table-tennis ball sized eggs.

159

REPTILES
Lizards

Around 3,000 species of lizard are known, over 50 of which occur in Europe. They range in size from geckoes about 6 cm long to the Eyed Lizard, which can grow to a total length of 80 cm. Most are agile; some species have adhesive pads on their toes enabling them to climb smooth surfaces and even hang upside down.

Most lizards feed on invertebrates, but many also eat fruit and other vegetable matter. Some of the larger species, such as the Eyed Lizard, eat small mammals, nestling birds and other lizards. Not all lizards have legs: several skinks have limbs reduced to vestiges, and the Slowworm and European Glass Lizards are completely legless. Most lizards have the ability to shed their tail (autotomy); when they are grabbed by it the predator is left with it writhing violently. The young of several species have brightly coloured tails, to draw attention away from the head and body. The majority of lizards lay eggs, but a few retain the eggs within the body in order to incubate them.

Moorish Gecko
Tarentola mauritanica

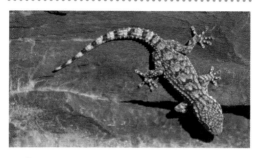

Size Up to 15 cm, including tail.
Habitat Trees, walls and around human habitation.
Food Insects and spiders.
Range Widespread on Mediterranean coasts, including islands. Well inland in Spain and Portugal.

A gecko with very obvious toe pads. It is usually grey, buff or brownish, and covered with swellings (tubercles); it frequently has some dark bands, particularly on the tail. It is extremely agile, and can run up smooth surfaces, and even cling to a rough ceiling and run upside down. It is mostly active by night and can often be seen hunting around lamps.

Agama

Agama stellio

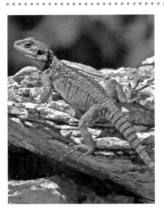

Size Up to 30 cm, including tail.
Habitat Olive groves, dry-stone walls and similar places.
Food Omnivorous; includes fruit and some animals.
Range Confined to Corfu and a few Aegean islands; also on the Greek mainland, near Salonika.

A large lizard with an extremely long, tapering tail. It is usually seen basking on walls and on trees, and it nods its head. Generally brown and rather spiny, particularly behind the head, the male becomes reddish when excited. Also known as the Hardun, it is probably not native to Europe, but may have been introduced several hundred years ago.

Chameleon
Chamaeleo chamaeleon

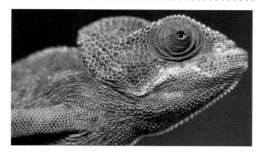

Size Up to 30 cm long, including tail.
Habitat Usually in bushes, often in arid areas.
Food Insects.
Range Mainly S Portugal and Spain, Crete and Sicily.

A fairly large, slow-moving lizard well known for its ability to change its colouring to match its background. It has a prehensile tail and grasping feet, with two toes forward and two back. The eyes can move independently of each other, and are covered with scaly lids. The Chameleon has an exceptionally long tongue, capturing insects on its sticky tip.

Large Psammodromus

Psammodromus algirus

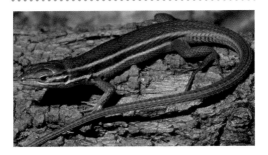

Size Up to 25 cm, of which the tail is 15 cm or more.
Habitat Usually in wooded areas with thick vegetation, including prickly pear.
Food Invertebrates.
Range Widespread across Spain and Portugal, and also in SW France.

A fairly large, long-tailed lizard, which is often very common. It is usually brownish above, with two pale cream stripes, and reddish-brown around the hind legs; some males have bright blue spots on the shoulders. It is usually found on or near the ground and when picked up may squeak loudly.

Spiny-footed Lizard
Acanthodactylus erythrurus

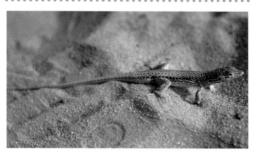

Size Up to 21 cm, of which the tail is about two-thirds.
Habitat Open areas, beaches and rocky plains.
Food Invertebrates.
Range Widespread over Spain and Portugal, except the north.

A medium-sized, ground-living lizard with a long tail. The markings are often striking: adults vary from grey to brown, with up to 10 creamy stripes, as well as dark blotches. The hatchling lizards are quite unlike the adults, the body being covered with black and white stripes and the tail bright orange-red.

Eyed Lizard
Lacerta lepida

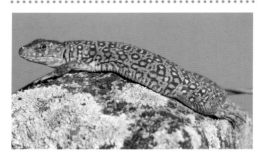

Size Up to 60 cm, of which the tail is up to 40 cm.
Habitat Farmland, olive groves and vineyards.
Food Invertebrates and small animals; some fruit.
Range Widespread in Spain and Portugal. Also in S France and extreme NW Italy.

A very large, green lizard with a massive head and often bright blue 'eyes' or ocelli along the sides. In the past, animals of up to 80 cm long were recorded, but such large specimens are much rarer now. It preys on insects and invertebrates when young, but the adult eats other lizards, baby mice and nestling birds.

Green Lizard
Lacerta viridis

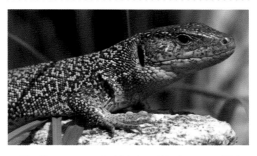

Size Up to 40 cm, of which the tail is about two-thirds.
Habitat Well-vegetated areas, hedges and glades.
Food Invertebrates and some fruit.
Range Most of Europe, north to Jersey, south to
N Spain, Italy and Sicily, and E Europe.

The male Green Lizard has a larger head than the
female, and also has a blue throat and chin. Like
many other lizards, the hatchlings are markedly
different from the adult, being uniformly olive-
brown, or with 2 or 4 pale stripes down the back;
they gradually become green and yellow as they
mature, the mixture often appearing 'beaded'.

167

Sand Lizard

Lacerta agilis

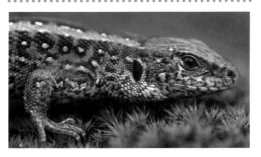

Size Up to 23 cm, of which the tail is up to 14 cm.
Habitat Wide variety, mostly sandy heath in north,
but well-vegetated upland up to 2,000 m in south.
Food Mostly invertebrates.
Range Widespread in C and E Europe, north to
Scandinavia; absent from Spain, Portugal and Italy.

This small lizard is similar in proportions to the
green lizard. It is widespread throughout Europe
(including England), but in the north it is mainly
confined to heath. As this habitat is being largely
destroyed, it is now endangered in many areas. It
lays eggs, but, in the north, they often fail to hatch.

Common Lizard
Lacerta vivipara

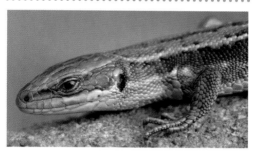

Size Up to 20 cm, of which the tail is up to 12 cm.
Habitat Variable, but usually in relatively damp areas.
Food Mostly invertebrates.
Range Europe, except most of the Mediterranean area.

The most widespread and abundant lizard in Europe. Its range extends north to Scotland and the Arctic Circle; it is able to survive in such cold areas by keeping its eggs within the body. By basking in the sun the female incubates the eggs, which hatch within her. The young are born almost jet-black – even the adult is relatively dark – in order to absorb the maximum of the sun's warmth.

Iberian Rock Lizard

Lacerta monticola

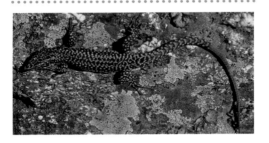

Size Up to 21 cm, of which the tail is up to 15 cm.
Habitat Confined to areas above 1000 m,
often near the tree line.
Food Invertebrates.
Range Populations in Spain, Portugal and France.

A very variable small lizard, adapted to living at
high altitudes with long winters. Although some
individuals are brownish and easily confused
with other small lizards, others are brilliantly
marked bright turquoise green with black
marbling; they normally all have a greenish belly.
The young are dark-bodied, but have a bright
turquoise tail for distracting predators.

Italian Wall Lizard

Podarcis sicula

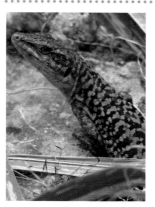

Size Up to 25 cm, of which the tail is up to 16 cm (usually smaller).
Habitat Very variable; includes road verges, vineyards, town parks and scrubland.
Food Invertebrates; also fruit and other plant matter.
Range Italy, Sicily, Corsica and Sardinia, and other nearby islands.

The Italian Wall (or Field) Lizard is probably the most variable in appearance of all the small lizards, but the only species it is likely to be confused with is the Common Wall Lizard, which normally has some dark markings on its underside. It is highly adaptable, and is found in towns and cities, often in and around human habitations.

Lilford's Wall Lizard

Podarcis lilfordi

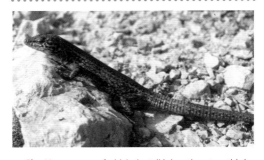

Size Up to 20 cm, of which the tail is less than two-thirds.
Habitat Rocky islands, with little vegetation.
Food Invertebrates, and also vegetable matter.
Range Confined to Mallorca, Menorca and nearby islands and islets.

A very variable lizard that ranges from almost black to a more typical lizard colouring of green on the back and spotted on the sides. The underside is white, orange or yellowish. Black individuals have bluish spots on the sides. It is a remarkably hardy lizard, often living on islands that are almost bare rocks.

Slow Worm

Anguis fragilis

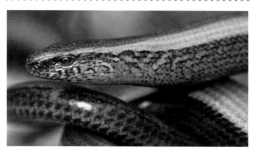

Size Up to 50 cm, but usually much less.
Habitat Thickly vegetated areas.
Food Invertebrates, including slugs and earthworms.
Range Across most of Europe, except Ireland, S Spain, Portugal and N Scandinavia.

The Slow Worm is a legless lizard. It is very smooth-scaled and generally dullish-brown (although males may have blue spots); the tail is easily shed leaving it rather blunt. The female usually gives birth to live young, but sometimes lays eggs that hatch almost immediately. At birth the young are like little golden needles, black on the underside.

European Glass Lizard

Ophisaurus apodus

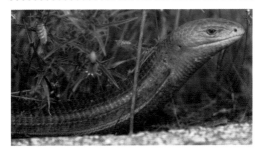

Size Up to 1.4 m, but usually much less.
Habitat Dry rocky hillsides, usually with bushes.
Food Invertebrates and small animals.
Range Confined to E Europe, extending north to Istria.

This is a larger relative of the Slow Worm (p.173). It is thick-bodied and, unlike snakes, it has an obvious groove down each side. The skin is very smooth and has a glassy appearance. It is usually found in dry habitats, often basking in bushes, and it makes a lot of noise as it rustles through undergrowth when disappearing from an intruder. It lays up to 10 eggs.

Three-toed Skink

Chalcides chalcides

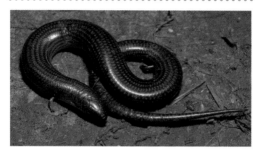

Size Up to 40 cm, of which the tail is up to 20 cm.
Habitat Grassy meadows and well-vegetated areas.
Food Invertebrates.
Range Spain, Portugal and Italy; also extreme
S France, and on Sicily and Sardinia.

The Three-toed Skink is particularly long and slender, with a shiny appearance. The body is often striped and the legs are very short, with only three toes. It is active by day, extremely agile, and so fast that it can scarcely be seen as it moves across the surface of vegetation. The female gives birth to 20 or more live young.

Snakes

Of some 2,700 species of snake worldwide, about 28 occur in Europe. They are all long-bodied and lack legs, though some have spur-like vestiges. The eyes are covered with a scale, but they do not have movable eyelids, unlike most lizards. All snakes are predatory, usually only taking live prey; their jaws are very loosely attached and consequently they are able to swallow relatively large prey.

The vipers have fangs which can inject poison. While some species (particularly in Eastern Europe) are extremely dangerous, others, such as the Adder, rarely cause fatalities, and certainly do not justify the widespread persecution they receive. Adders have courtship 'dances' and give birth to living young, although the majority of European snakes lay eggs. Snakes are generally active by day, and often bask in the sun, particularly in the early morning. However, during the hotter months in southern Europe some species are more active at night.

Montpellier Snake
Malpolon monspessulanus

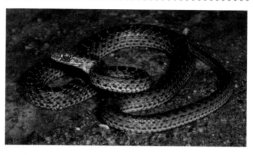

Size Up to 2 m.
Habitat Dry rocky places with some thick vegetation.
Food Mammals, lizards and birds.
Range Spain, Portugal, Mediterranean coast of France, N Italy, S Balkans and a few Greek islands.

A large snake with 'eyebrows', which give it a staring expression. It has venomous fangs at the back of the jaw, which it uses to subdue its prey; a bite can cause numbing in humans (occasionally a fever), but this is rarely dangerous. It lays up to 20 eggs, and the newly hatched young may have varying spotted markings down the back.

Horseshoe Whip Snake

Coluber hippocrepis

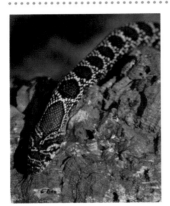

Size Up to 1.5 m.
Habitat Dry rocky hillsides, dry-stone walls.
Food Young eat lizards; adult eats mammals and birds.
Range Spain, Portugal and SW Sardinia.

The pattern of this attractively marked snake is distinctive, and, as its name suggests, there is often a 'horseshoe' or V mark at the back of the head. The young, as in most snakes, have brighter and more clearly defined markings. Although mainly terrestrial, it will climb in bushes, and is often found around human dwellings. It lays up to 10 eggs.

Western Whip Snake

Coluber viridiflavus

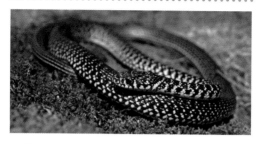

Size Up to 2 m, but usually under 1.5 m.
Habitat Dry, often rocky areas, with thick vegetation.
Food Lizards, snakes, mammals and birds;
the young prey on invertebrates and small lizards.
Range From NE Spain and W France to Switzerland,
Italy, Sicily, Sardinia, Corsica and Malta.

A large, slender and fast-moving snake that is
aggressive if captured. Larger animals tend to be
fairly uniformly dark above and olive below, but
the young, and smaller adults, can be boldly
marked. Mainly active by day, and terrestrial, but
climbs well. It likes a very wide range of habitats,
and lays up to 15 eggs.

Leopard Snake

Elaphe situla

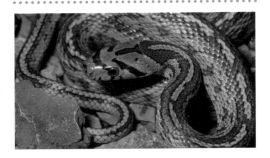

Size Up to 1 m.
Habitat Usually dry, rocky areas below 600 m.
Food Rodents, lizards and nesting birds.
Range Scattered populations in S Italy, Sicily and the Balkan Peninsula, and some Greek islands.

One of the most attractively coloured of all European snakes, the Leopard Snake is also one of the rarer species. It is unusual in so far as the adult retains the contrasting markings of the young snake. It is sometimes seen around houses, where it preys on rodents. When alarmed, it vibrates its tail like a rattlesnake. It lays 2–7 eggs.

Aesculapian Snake

Elaphe longissima

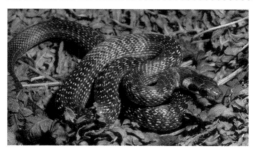

Size Up to 2 m, but usually under 1.5 m.
Habitat Generally in dry but well-vegetated areas.
Food Small mammals, birds and lizards.
Range C and S Europe, but absent from most of Spain and Portugal.

This is the snake associated with the God of Medicine (Asklepios in Greece, Aesculapius in Rome), and it is possible that its range in the north of Europe was as a result of movements by the Romans. It is large, but quite fast, and frequently climbs in bushes and sometimes even up vertical tree-trunks. It lays up to 15 eggs.

Ladder Snake
Elaphe scalaris

Wild Animals

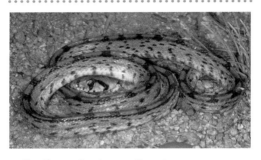

Size Up to 1.6 m, but usually under 1.2 m.
Habitat Warm, stony places, olive groves and vineyards.
Food Young eat invertebrates; adults eat birds, and mammals up to the size of young rabbits.
Range Spain, Portugal, Minorca and far S of France.

A large snake with a pointed snout. The young are attractively marked with a ladder-like dark pattern on an olive background. They gradually become more uniform in colour, and the markings reduce to two stripes down the back in adults. It can be aggressive when captured, but it is not venomous. It lays up to 12 eggs.

Grass Snake
Natrix natrix

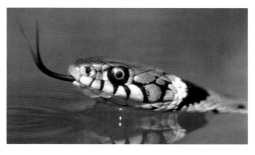

Size Up to 2 m, but usually under 70 cm.
Habitat Usually close to water, but also woodland.
Food Amphibians, fish, small birds and mammals.
Range All Europe, except Ireland and N Scandinavia.

The Grass Snake is one of the best known and most widely distributed of European snakes. It is usually green with some barring, and in most parts of Europe it has a yellow or orange collar. It can grow quite large, and is found in a wide range of habitats, but generally near water, where it frequently hunts. It lays up to 50 eggs, in rotting vegetation or manure heaps. It often feigns death when captured.

Viperine Snake
Natrix maura

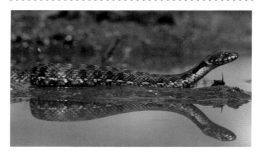

Size Up to 1 m, but usually under 70 cm.
Habitat Generally near water.
Food Mostly amphibians and fish.
Range W Europe and Sardinia.

The Viperine Snake is superficially like the Grass Snake (p.183), but is even more closely associated with water. It takes its name from its zigzag pattern and its defence mechanism: when disturbed, it usually draws its body into coils, flattens the head into a triangular shape and hisses and lunges – imitating the venomous vipers.

Wild Animals

Smooth Snake
Coronella austriaca

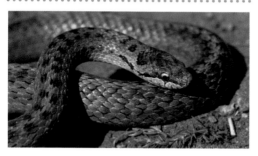

Size Up to 80 cm, but usually under 60 cm.
Habitat Heathland in England; elsewhere more varied.
Food Mostly lizards and Slow Worms.
Range Widespread across Europe, but absent from most of the British Isles, S Spain and Portugal.

This is a relatively small snake, usually buffy brown, with darker blotches or stripes. In Britain it is extremely rare, because it lives exclusively on heathland in southern England, much of which has been gradually destroyed. In the south of its range it is found at altitudes of up to 1,800 m. The female gives birth to up to 15 live young.

Southern Smooth Snake

Coronella girondica

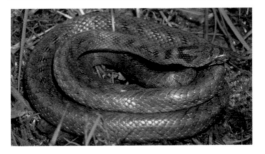

Size Up to 50 cm.
Habitat Mostly dry areas, including rocky habitats and stone walls.
Food Mostly lizards and geckoes.
Range Spain, Portugal, S France, Italy and Sicily.

Very similar to the Smooth Snake (p.185), the southern species is slimmer, smaller and generally more boldly patterned. The former, with its more northerly distribution, gives birth to live young, but the Southern Smooth Snake lays up to 10 eggs. When handled it is docile, rarely bites and soon tames.

Wild Animals

Adder

Vipera berus

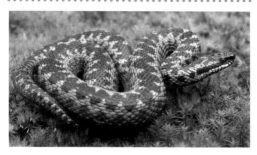

Size Up to 90 cm, but usually under 65 cm.
Habitat Very variable. Drier, more open areas in north of range; up to 3,000 m in mountains in the south.
Food Small mammals and lizards.
Range Widespread, often abundant, except Ireland, Spain, Portugal, Italy and most Mediterranean islands.

The most widespread viper, its range extends to the Arctic Circle. Its colouring varies, but it usually has a zigzag pattern down the back. The female gives birth to live young. It is venomous from birth, and can be very aggressive if handled but, although serious, the bite is rarely fatal to humans.

Asp Viper

Vipera aspis

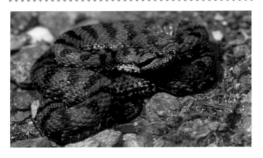

Size Up to 75 cm, but usually under 65 cm.
Habitat Varied, from lowlands to 3,000 m in the Alps.
Food Mostly small mammals, and some birds.
Range N Spain, France, Switzerland, Italy and Sicily.

An extremely variable viper, with the typical triangular head, and a pattern that may be a zigzag, stripes or bars. Completely black animals are not unusual, particularly in Switzerland and north and central Italy. The tip of the snout is slightly upturned. Its bite is more venomous than the Adder (p.187), though it may vary regionally, and human deaths have occurred.

Lataste's Viper

Vipera latasti

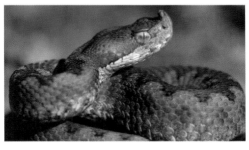

Size Up to 75 cm, but usually under 60 cm.
Habitat Generally dry, often rocky habitats.
Food Lizards, small mammals and invertebrates.
Range Confined to Spain and Portugal.

This snake has the typical head shape and build of a viper, but is the only viper in its range to have a prominent nose-horn. Its pattern and colouring are similar to other species of viper, the background usually being greyish or brownish. Although it can be aggressive, its bite is normally not dangerous to humans. Like several of the species found in Spain, it is also found in North Africa.

INDEX

● ●

Square brackets indicate passing reference. Bold entries show groups.

Wild Animals

Index

Picture credits:

p. 21 © Paul Hobson/FLPA; p. 22 © NORBERT WU/Minden Pictures/FLPA; p. 23 © Phil McLean/FLPA; p. 24 © Derek Middleton/FLPA; p. 25 © Derek Middleton/FLPA; p. 26 © Panda Photo/FLPA; p. 27 © Derek Middleton/FLPA; p. 28 © Panda Photo/FLPA; p. 29 © David Hosking/FLPA; p. 31 © HUGO WILLOCX/FOTO NATURA/FLPA; p. 32 © David Hosking/FLPA; p. 33 © HUGO WILLOCX/FOTO NATURA/FLPA; p. 34 © Silvestris Fotoservice/FLPA; p. 35 © HUGO WILLOCX/FOTO NATURA/FLPA; p. 36 © Silvestris Fotoservice/FLPA; p. 37 © Derek Middleton/FLPA; p. 38 © Michael Clark/FLPA; p. 39 © Michael Clark/FLPA; p. 40 © Hannu Hautala/FLPA; p. 41 © Hugh Clark/FLPA; p. 42 © HUGO WILLOCX/FOTO NATURA/FLPA; p. 43 © Silvestris Fotoservice/FLPA; p. 44 © Roger Hosking/FLPA; p. 45 © HUGO WILLOCX/FOTO NATURA/FLPA; p. 46 © LARS SOERINK/FOTO NATURA/FLPA; p. 48 © ERIC WANDERS/FOTO NATURA/FLPA; p. 49 © Tom Vezo/Minden Pictures/FLPA; p. 50 © Michael Durham/FLPA; p. 51 © Roger Tidman/FLPA; p. 55 © Phil McLean/FLPA; p. 56 © Tony Hamblin/FLPA; p. 57 © John Holmes/FLPA; p. 58 © David Hosking/FLPA; p. 59 © MIKE LANE/FLPA; p. 60 © JORN PILON/FOTO NATURA/FLPA; p. 61 © Derek Middleton/FLPA; p. 62 © Derek Middleton/FLPA; p. 63 © HUGO WILLOCX/FOTO NATURA/FLPA; p. 64 © Winfried Wisniewski/FLPA; p. 65 © Mike Lane/FLPA; p. 66 © Tony Hamblin/FLPA; p. 67 © WIL MEINDERTS/FOTO NATURA/FLPA; p. 68 © Terry Whittaker/FLPA; p. 69 © Sunset/FLPA; p. 70 © Andy Sands/naturepl.com; p. 71 © HUGO WILLOCX/FOTO NATURA/FLPA; p. 72 © David Hosking/FLPA; p. 73 © Peter Wilson/FLPA; p. 74 © HUGO WILLOCX/FOTO NATURA/FLPA; p. 75 © Derek Middleton/FLPA; p. 76 © Andy Sands/naturepl.com; p. 77 © CISCA CASTELIJNS/FOTO NATURA/FLPA; p. 81 © Winfried Schäfer/Imagebroker/FLPA; p. 83 © Thomas Sbampato/Imagebroker/FLPA; p. 84 © Michael Krabs/Imagebroker/FLPA; p. 85 © Panda Photo/FLPA; p. 86 © Martin B Withers/FLPA; p. 87 © Elliott Neep/FLPA; p. 88 © Mike Lane/FLPA; p. 89 © Rolf Bender/FLPA; p. 90 © CHRIS SCHENK/FOTO NATURA/FLPA; p. 91 © Derek Middleton/FLPA; p. 92 © S & D & K Maslowski/FLPA; p. 93 © Jurgen & Christine Sohns/FLPA; p. 94 © Michael Krabs/Imagebroker/FLPA; p. 95 © AD VAN ROOSENDAAL/FOTO NATURA/FLPA; p. 96 © FLIP DE NOOYER/FOTO NATURA/FLPA; p. 97 © John Tinning/FLPA; p. 98 © Michael Krabs/Imagebroker/FLPA; p. 99 © Michaela Walch/Imagebroker/FLPA; p. 100 © Gerard Lacz/FLPA; p. 101 © Ingo Schulz/Imagebroker/FLPA; p. 105 © Silvestris Fotoservice/FLPA; p. 106 © Michael Krabs/Imagebroker/FLPA; p. 107 © Mitsuaki Iwago/Minden Pictures/FLPA; p. 108 © S Jonasson/FLPA; p. 109 © MICHIO HOSHINO/Minden Pictures/FLPA; p. 111 © DUNCAN USHER/FOTO NATURA/FLPA; p. 112 © David Hosking/FLPA; p. 113 © Alfred Schauhuber/Imagebroker/FLPA; p. 114 © Michael Durham/FLPA; p. 115 © Bernd Zoller/Imagebroker/FLPA; p. 116 © CYRIL RUOSO/JH EDITORIAL/Minden Pictures/FLPA; p. 117 © WIM WEENINK/FOTO NATURA/Minden Pictures/FLPA; p. 118 © MARK RAYCROFT/Minden Pictures/FLPA; p. 119 © Hannu Hautala/FLPA; p. 120 © Robert Canis/FLPA; p. 121 © Robert Canis/FLPA; p. 121 © Elliott Neep/FLPA; p. 122 © Simon Litten/FLPA; p. 123 © Simon Litten/FLPA; p. 127 © Tui De Roy/Minden Pictures/FLPA; p. 128 © FLIP NICKLIN/Minden Pictures/FLPA; p. 129 © Gerard Lacz/FLPA; p. 130 © Terry Whittaker/FLPA; p. 131 © Mammal Fund Earthviews/FLPA; p. 133 © Anton Luhr/Imagebroker/FLPA; p. 134 © Stefan Huwiler/Imagebroker/FLPA; p. 135 © Martin B Withers/FLPA; p. 136 © Martin B Withers/FLPA; p. 137 © Marko Konig/Imagebroker/FLPA; p. 138 © RENE KREKELS/FOTO NATURA/Minden Pictures/FLPA; p. 139 © RENE KREKELS/FOTO NATURA/FLPA; p. 140 © Derek Middleton/FLPA; p. 142 © HUGO WILLOCX/FOTO NATURA/FLPA; p. 143 © Paul Hobson/FLPA; p. 144 © RENE KREKELS/FOTO NATURA/Minden Pictures/FLPA; p. 145 © Wayne Hutchinson/FLPA; p. 146 © G.E.J. TIK/FOTO NATURA/FLPA; p. 147 © Yossi Eshbol/FLPA; p. 148 © Alfred & Annaliese Trunk/Imagebroker/FLPA; p. 149 © John Hawkins/FLPA; p. 150 © KONRAD WOTHE/Minden Pictures/FLPA; p. 152 © B. Borrell Casals/FLPA; p. 153 © Hans Dieter Brandl/FLPA; p. 155 © Chris Mattison/FLPA; p. 156 Jurgen & Christine Sohns/FLPA; p. 157 © Martin B Withers/FLPA; p. 158 © Fred Bavendam/Minden Pictures/FLPA; p. 159 © SA TEAM/FOTO NATURA/FLPA; p. 161 © MARTIN WOIKE/FOTO NATURA/FLPA; p. 162 © Michael Gore/FLPA; p. 163 © INGO ARNDT/FOTO NATURA/Minden Pictures/FLPA; p. 164 © Chris Mattison/FLPA; p. 165 © David Hosking/FLPA; p. 166 © John Hawkins/FLPA; p. 167 © Alfred & Annaliese Trunk/Imagebroker/FLPA; p. 168 © JAN VERMEER/FOTO NATURA/FLPA; p. 169 © Mike Lane/FLPA; p. 170 © Chris Mattison/FLPA; p. 171 © Neil Bowman/FLPA; p. 172 © Michael Rose/FLPA; p. 173 © Derek Middleton/FLPA; p. 174 © Richard Brooks/FLPA; p. 175 © Chris Mattison/FLPA; p. 177 © B. Borrell Casals/FLPA; p. 178 © Hans Dieter Brandl/FLPA; p. 179 © Michael Dietrich/Imagebroker/FLPA; p. 180 © Chris Mattison/FLPA; p. 181 © Chris Mattison/FLPA; p. 182 © B. Borrell Casals/FLPA; p. 183 © Derek Middleton/FLPA; p. 184 © HUGO WILLOCX/FOTO NATURA/FLPA; p. 185 © Derek Middleton/FLPA; p. 186 © Chris Mattison/FLPA; p. 187 © Mark Sisson/FLPA; p. 188 © Chris Mattison/FLPA; p. 189 © EDO VAN UCHELEN/FOTO NATURA/FLPA

Wild Animals